391.2 DAN

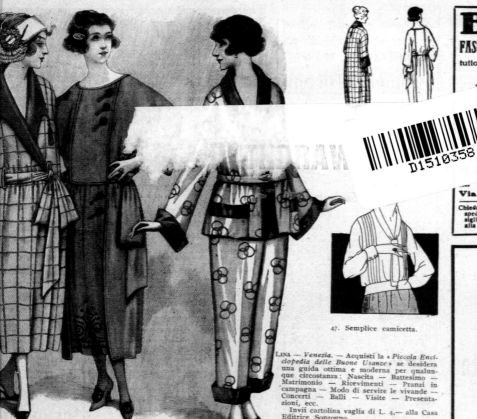

D1510358

47. Semplice camicetta.

LINA — *Venezia*. — Acquisti la « Piccola Enci-
clopedia delle Buone Usanze » se desidera
una guida ottima e moderna per qualun-
que circostanza : Nascita — Battesimo —
Matrimonio — Ricevimenti — Pranzi in
campagna — Modo di servire le vivande —
Concerti — Balli — Visite — Presenta-
zioni, ecc.
Invii cartolina vaglia di L. 4, — alla Casa
Editrice Sonzogno.

« PRIMAVERA » — *Pisa*. — Il verde forte si usa
molto e a Lei, che come mi dice, è bionda,
si adatterà benissimo. Il cappello di paglia
nera si porta con tutti gli abiti, così pure
le scarpette in camoscio. Le calze grigie
e color carne godono ancora molto favore.

46. Moderna veste da camera, elegante abito da casa e piyama.

— Potrà benissimo col-
lie e le poltrone. Metta
seta giallo-oro pallido.
mi parla sono eleganti
una camera da letto.
rio parere è da prefe-
ta. La trovo assai più
il numero dei capi si
del suo paese. Certo
re considerando che la
ricciosa ed instabile.
li ed auguri infiniti.

Acquisti « *Il corredo di*
 », Num. 6, troverà
un costume da bagno
Invii alla nostra Casa
 1,50, richiedendo il

o assolutamente fuori

MARIA — *Varese*. — I ricami in bianco sono
sempre favoriti dalla moda.
Le gonne corte sono fuori moda. Legga
« *Fammi bella* », di Mura, libro interessan-
tissimo e moderno.
Un'ottima tintura per capelli, la troverà
presso la Ditta Annichiarico - Via Becca-
ria, 1 - in Milano.

ABBONATA — *Torino*. — Le scarpe bianche si
puliscono con apposito spazzolino metallico
e con cervina bianca.
Potrà portare il cappello del quale mi
parla : con un abito noisette, o bianco, o
grigio, o lilla, o bleu.

FIOR DI PASSIONE. — Il ventaglio si porta in
mano. Gli abiti di organdi si stirano
molto umidi, senza gommarli. Può portare
il cappello nero, i brillanti, ecc. Preferirei
le calze nella tinta dell'abito o delle scarpe.
Saluti distinti.

ROSA THEA — *Treviso*. — Per ciò che riguarda
il colletto, sarà bene rivolgersi ad una tin-
toria. La copertina la preferirei in rosa ci-
clamino. È uscito il 2° fascicolo del « Cor-
redo di Bébé », ricco di riproduzioni di in-
dumenti di ogni genere, di modelli tagliati
e disegni. Costa L. 5. — Il volume che tratta
l'arredamento della casa non è ancora stam-
pato. Come tende, preferirei quelle in tela
di seta orlate a giorno. Regali un cartella
da scrittoio in pergamena o un bell'anello
d'oro. Saluti distinti.

CLORINDA — *Padusi*. — Tutte le tinte sono mo-
derne. La preferenza è data al rosso ed al
bleu.

MODE *series directed by Maria Luisa Frisa*

Elda Danese

The House Dress

A Story of Eroticism and Fashion

Marsilio MODE FONDAZIONE PITTI DISCOVERY

I would like to express my gratitude to the Fondazione Pitti Discovery, which has made the publication of this volume possible, and to all the people who have contributed to its realization: my special thanks go to Maria Luisa Frisa and Mario Lupano for having put their trust in this project, supporting the idea right from the start, and to Rossella Martignoni of the Marsilio publishing house for her thoughtful assistance. Amanda Montanari's help in finding the pictures to be included in the volume has been indispensable, while the information supplied by Winder Baker, Lizzie Bramlett, Elizabeth Flanagan, Yoshiko Wada and Susan Wick, especially in relation to the American production of housedresses, has been extremely useful. Teresa de Danieli and Carla Rossi Balducci have delved into their own memories, providing invaluable leads with their stories, while important information on Italian production has been courteously supplied to me by Paolo Abba, Ezio Calmonte and Luigi Fragiacomo.

translations
Huw Evans

picture research
Amanda Montanari

graphic design
Alessandro Gori.Laboratorium

front cover
Sophia Loren in *La ciociara*, directed by Vittorio De Sica, 1960

inside cover and page 1
Illustration of items of house wear,
in *La Moda Illustrata*, May 1922
page 152 and inside cover
Diane von Furstenberg advertising campaign, photos Bettina Rheims, 1997

The Fondazione Pitti Discovery regrets any photographic credits
that have been unintentionally omitted

first edition June 2008
ISBN 88-317-9525

Contents

Introduction

The history of fashion is written predominantly from the perspective of its "high" end: even today the documentation and study of forms of "popular" clothing are generally considered more appropriate subjects for analysis by ethnographers and anthropologists and by students of the history of material culture. With the exception of examples relating to the fashions of subcultures and to street style, it can be said that some forms of popular dress have been neglected even by that strand of research which, since the end of the sixties, has led to a programmatic breakdown of the boundaries between different disciplinary areas: a trespassing that has provided an illuminating perspective of the emergence of phenomena in fashion and the changes in social behavior linked to it.

As is well known, these are researches that, overcoming the tunnel vision of the classical theories in which the phenomenon of fashion is described in terms of social dynamics, as the product of a relationship of creation and imitation between the different classes, have turned their attention in particular to the forms of production and reworking of fashions by youth culture as well as to the different aspects assumed by fashion in both its global and its local circulation.

If some forms of dress, notwithstanding this widening of the limits of inquiry, have not received sufficient attention, this can also be attributed to their low visibility, due to the fact that they are not part of the traditional circuit of production, communication and consumption of fashion and that they follow a different cycle from that of the rapid changes typical of that circuit: the housedress is one

of these. It is obvious on the other hand that, despite its marginal position in the world of fashion, it cannot be considered extraneous to that cultural dimension of individual expression and communicative function which is inevitably connected with every choice in dress; all garments, even the ones that seem to have been designed and adopted for reasons of a functional character, such as sportswear or work clothes, shape and convey personal and cultural attitudes.

The transverse character of the housedress, the way it has made its way into different social and geographic dimensions and has adapted to different needs, has made the confines of the research conducted in this volume porous. Although the imagery associated with this item of clothing chiefly calls to mind a working-class and rural setting, it is also true that many formal and historical references lie outside this context, and that this garment lends itself to a multitude of uses: it can be worn exclusively for housework or as an item of casual wear, with variations that characterize its use in the countryside or in the suburbs, in middle-class homes or on the streets of towns and villages. Finally, the form of the housedress was adapted to the altered social condition of women in the seventies through its rehabilitation by several fashion designers, and this has been followed, in more recent years, by reappraisals that have renewed its popularity among the female public.

Despite the garment's widespread use, the sources that document its origins and diffusion are few and far between, just as the images that reflect its evolution are wanting. As an item of clothing worn at home, the housedress has followed the changes in the domestic role of women and, like household chores and family life, eludes any precise delimitation. Nor does it lend itself easily to historical analysis.

In order to seize every opportunity of tracking down elements that may help to define the many-sided identity of this item of clothing, we have chosen here to broaden the horizon of our inquiry and make use of a variety of sources capable of providing data and information on the relationship between the transformation of the

housedress, the domestic environment and the role that women were called on to play in it.

On this plane the cinema, especially the Italian one of the years following the Second World War, is an extremely rich source of images and examples that bear witness to the potent presence of the housedress in the collective memory, and demonstrate its capacity to express a significant part of the culture of a period that would otherwise by difficult for us to understand.[1] The cinema has proved to be a highly significant iconographic resource, an important aid in documenting both the multiple connotations of clothing and the representation of the female image associated with it: this source has been utilized, naturally, in the awareness that the costume is never a simple reproduction of actual clothing and that, "as fictional garments, the costumes in movies [...] can be regarded as a separate practice of dressing, linked to its own symbolic processes, both within and beyond a film."[2]

NOTES

[1] This is a now well-established use of the movie, which has its roots in the positions of the school of Les Annales and which has been supported by many scholars. The French historian Marc Ferro has explained very well, as Antonio Costa points out, the reasons and the way in which "the cinema can be seen as a source, i.e. a factor in historical documentation [...], and as an agent of history" (Antonio Costa, "Cinema luogo di storia," in *Segnocinema*, no. 2, 1981, p. 19).

[2] Antonella Giannone and Patrizia Calefato, *Manuale di comunicazione, sociologia e cultura della moda*, vol. V, *Performance*. Rome: Meltemi, 2007, p. 18.

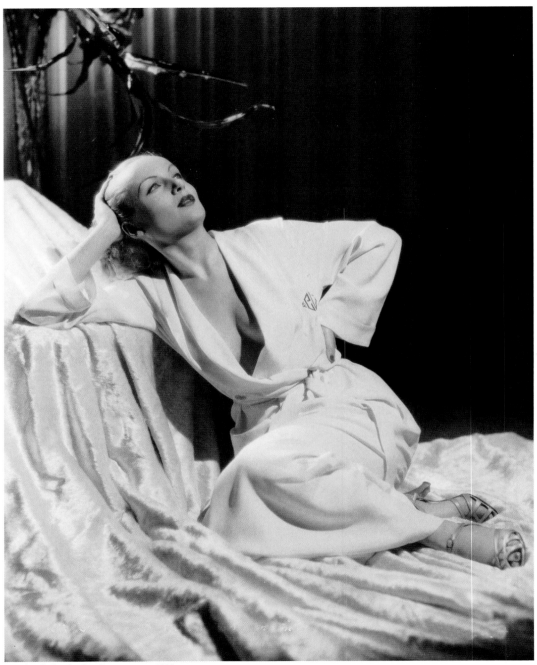

Carole Lombard in dressing gown, 1933.
Getty Images Archive

The What and Where of the Housedress

The origin of the English word housedress is self-evident, but in other countries the garment goes by many different names. In Italy it is called a *vestaglietta*, a term that is now part of everyday language but which did not make its appearance in Italian dictionaries until relatively recent times. The word was not included in the 1967 edition of the Devoto-Oli dictionary, nor in the Zingarelli of 1965. The edition of the *Dizionario Garzanti della Lingua Italiana* for that year, however, gives two definitions of the term: 1) "diminutive of *vestaglia* (also in the derogatory sense)"; 2) "simple and comfortable woman's dress, open at the front, for wear at home or at the seaside."
The entry had been present in a number of dictionaries for several years, but only in its most straightforward sense as a diminutive of *vestaglia*, "dressing gown" or "robe." This term had entered the Italian vocabulary in the 19th century, and was probably derived from *vestagia*, a word in the Venetian dialect,[1] rather than, as has been argued elsewhere, the medieval French word *vestaille*.[2] In any case the word *vestaglia* cannot have found ready acceptance if we consider that in his dictionary published in 1931 Petrocchi hinted at his own reluctance to make use of it by declaring that "some call the dressing gown worn by women by this name."[3] Even Cesare Meano, in his 1936 dictionary of fashion terms, declared with a certain lack of enthusiasm that the word had established itself as a neologism, adding that : "[...] some purists are still loath to make use of this word; others accept it, considering that it calls something elegant to mind and is therefore better suited to the object in question than the generic *veste* ["dress, gown, robe"]."[4]

These purist reservations do not seem to have hindered the entry of the term *vestaglia* into common parlance, nor of its diminutive, as is apparent, for example, from its use by Luigi Pirandello in a play of 1929, *O di uno o di nessuno*, where the heroine Melina is described as wearing "*una vestaglietta di tenerissimo colore azzurro, leggera.*"[5] In his *Commentario*, Meano also includes the entry "*vestaglietta*," but uses it in a sense not encountered in other sources, to denote "an elegant short jacket" to be worn over the nightgown; in other words a bed jacket, a garment for which Italians normally use the French word *liseuse*. It is likely that, as elsewhere in his dictionary, the author's desire to find alternatives to the Gallicisms that abound in the vocabulary of fashion had induced him to utilize the term in a fanciful and inappropriate manner.

While the etymology of the Italian word "*vestaglietta*" is obvious, the reasons for its semantic drift toward a particular kind of woman's clothing appear more complicated. The characteristics of the *vestaglietta* were described precisely in the Treccani dictionary of 1994, thirty years after the first concise definition given above: "[...] in women's clothing, a light dress, with or without sleeves, open and fastened with a row of buttons at the front, or crossed in front with two ribbons tied at the back: a dress of printed cotton, of linen; a *vestaglietta* of printed cotton, of linen; a *vestaglietta* worn at home, at sea or on the beach."[6]

Each of the characteristics set out above delineates the appearance of the garment that is the subject of this book and has been taken as a point of reference for reconstructing its history and tracing its presence in various cultural and social contexts, as well as for following its evolution over a long period that has seen the passage of broad strata of the female population to a modern way of life. The history of the *vestaglietta* or housedress goes hand in hand with the development of the modern form of women's wear between the two world wars, with an identity that oscillates, in a wide semantic range, between that of a garment put on for housework and that of the seductive robes worn by the stars of Hollywood. This article of clothing, which was first produced on an industrial scale in the

United States, has come to be adopted, in different ways and at different times, in all modern Western cultures and, in many cases, in other parts of the world as well. Its specific function of a garment put on by women to do their household chores has turned into that of an item of everyday wear for women in rural families or become confused with that of the light dresses worn for summer vacations. As far the entry of the *vestaglietta* into the wardrobe of many Italian women is specifically concerned, it is necessary to look at a period, between the 1920s and the 1930s, in which the traditional women's clothing typical of rural areas was joined and then replaced by a different way of dressing. This is further evidence of how both geographical boundaries – from regional to international ones – and the possibilities of social and individual identification through a particular code of dress could no longer be precisely defined. This change has to be seen in relation to the progressive urbanization of rural families and the growing effect of the diffusion of new models of aesthetic and social conduct proposed by the press and cinema. During the years of Fascism, notwithstanding the regime's images of pageants of rural housewives in regional costume, interest in fashion was spreading even in the villages and countryside, especially among young women.

In parallel, the tradition of wearing an apron tied at the waist, a badge of manual and menial labor that used to mark out the lower classes and their relationship with physical work and the material world, was vanishing. In Italy the apron was a characteristic element of all the regional women's costumes: thus with the progressive disappearance of traditional work clothes and of their Sunday version, in which the presence of a piece of fabric in a contrasting color assumed a symbolic value, a modern form of everyday wear emerged in which the strong indication of regional or class differences was reduced. The apron did not vanish completely from the dress of women who worked in the fields or at home, but was transformed into an accessory for occasional wear, when particular kinds of work were being carried out.

Before the shift to industrial production in Italy took place, in the

1950s and 1960s, most women's clothing was made at home, and in this context the distribution of paper patterns – which had been produced at an international level since the middle of the 19th century – had helped many women to increase the range of possibilities for adapting their clothing to changing fashions. The circulation of magazines with enclosed paper patterns, such as *La Moda Illustrata*, contributed to the popularity of types of dress that were easy to make, models that were often adapted by their users to their own sewing skills and financial resources. Illustrated magazines and *fotoromanzi* or picture stories, a genre created in Italy immediately after the Second World War, were another source on which women could draw to keep up with new fashions. David Forgacs and Stephen Gundle, in their recent study of mass culture and Italian Society in the years from Fascism to the Cold War, cite the testimony of a woman who recalls the spell cast on her by the image of a dress with all the characteristics of a *vestaglietta* which appeared on the cover of a picture-story magazine in 1946:

[...] In the first issue [of *Grand Hotel*] there was a smock on the cover, in red-and-white checks, small checks like this, I still have a bit of it, which I used later to make a shirt for Beppe [her son] when he was little. I bought the same fabric – I found it, it was easy then to find a white check – and I went home and said: "my mom must make me this smock." It was buttoned all the way down the front, a little dress [that] was really beautiful.[7]

The new form of the dress to be worn at home was modeled on a series of different suggestions, linked both to the redefinition of cultural and social boundaries and to the spread of new means of mass communication. One of these sources was the dressing gown or robe which, emerging as an expression of Western myths about the Orient, then developed into a form for daytime use called the housecoat. While the robe lost some of its exotic charm along the way, in compensation it acquired a new and potent seductive allure through a medium of great communicative and trend-setting power like the cinema. It was through the movies that the dressing gown, in the years between the two world wars, acquired an extraordinary

visibility and expressivity, especially for female moviegoers fascinated by the drapery of the satin robes worn by international stars.

More in general, the cinema was a highly effective vehicle for a contemporary dimension of clothing, a cosmopolitan mode of dressing: in rural areas and provincial towns of Italy the new cinematographic models and myths played a decisive role in persuading women to abandon traditional forms of dress and in encouraging, among other things, the adoption of the *vestaglietta.* A similar metamorphosis had seen the transformation of the *vestaglia,* from the middle of the 19th century onward, into a garment to be worn after taking a bath in the tub, a practice that the naïve enthusiasm for hygiene of that period had led people to see, as Rosita Levi Pisetzky argues, "almost as a ritual of a scientific or sporting character."[8] Later on, in the passage from the small domestic tub of water to the broader expanse of the sea, the *vestaglia* had remained the standard article of clothing for wear after bathing. And another element of domestic intimacy, the pair of pajamas, had also been turned into an item of casual wear for the new custom of visiting the beach.

Exposure of the dressed and undressed body to the air and sun had become a very widespread practice in the years between the wars, reflecting the attention paid by modernist culture to the body. The space that Cesare Meano's aforementioned *Commentario* devoted to the "sun costume" was justified by the popularity of these practices, of which the author approved so long as they were free of "naturist or nudist excesses."[9] In this connection, he recommended the use of an ensemble composed of a pair of very short pants with a bib and a "straight and simple jacket, descending as far as the knees," which could be taken off with a "small and rapid gesture" in order to sunbathe. A further advantage of this outfit was that it could be used "wherever the sun shines," like "any garment in fashion a few years ago," letting "whoever wore it pass unobserved, in the most precise sense of the expression."[10]

In addition to the proposal of an item of clothing appropriate to

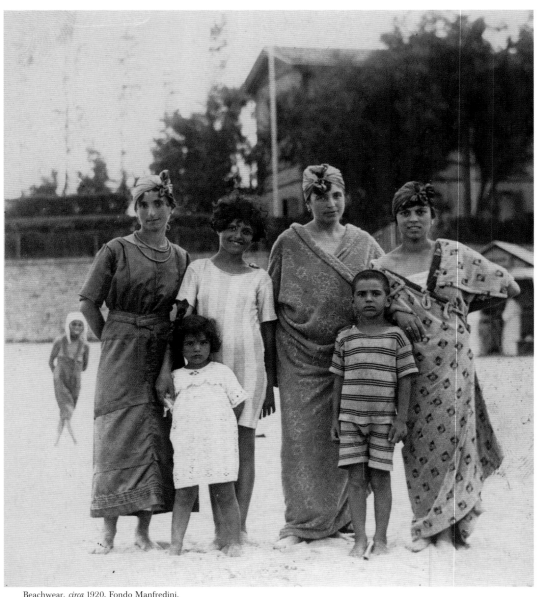

Beachwear, *circa* 1920, Fondo Manfredini.
Archivio Fotomuseo Giuseppe Panini, Modena

hygienic practices, the transformation of the robe was presented in the same text with arguments that expressed a tendency toward modernity, but also continued to represent "a paternalistic and conservative model of femininity."[11] In a long passage Meano describes the evolution of the robe toward a modern form, telling the story of the transformation of a flimsy and elaborate composition of voile and lace into a garment closer in its character to men's clothing. This was, in the author's view, the result of a long negotiation on the part of the women for the use of pants: before succeeding in wearing them publicly for the vacations and to play sports, they had limited themselves to putting them on in the privacy of their homes, donning pajamas of male cut. The acceptance of the use of pants outdoors was counterbalanced, according to Meano, by the return of the robe in the home: thus its new form was a consequence of the lengthening of the pajama jacket and the subsequent elimination of the pants from the outfit.

The simplified and modern form of a garment like the robe, linked to the intimacy of the home and a strictly private use, had therefore been superimposed on that of an article of clothing suited to the rapid action of undressing and dressing on the beach, and thus accompanied the exposure of the body in a public space: the convergence of these two models was summed up in a garment of multiple identities like the *vestaglietta.*

In Italy the image of beachwear would be closely bound up with the history of the first mass vacations at the seaside, where families would sit under umbrellas. This new habit of health and recreation experienced a boom after the Second World War in step with the rise in prosperity, with the growth in the number of automobiles and with the introduction of a period of paid vacations for wage earners. In Carlo Cassola's novel *Un cuore arido,* written in 1949 and set in the Tuscany of the 1930s, the description of a Sunday outing to the beach by two young women who "had put their costumes on under their robes, and brought towels of sponge cloth with them,"[12] presents us with an image of the *vestaglietta* in the context of this new custom.

Another example can be found in a 1941 novel by Cesare Pavese, *La spiaggia*, in which the author used the wearing of a *vestaglietta* on the beach during a seaside vacation to show that a female character did not fit into that setting:

Near our umbrella I glimpsed Berti as he moved away – the black back, the swimming trunks – speaking with an agitated air to a small woman in a bizarre flowered robe, with high-heeled sandals and shiny powdered cheeks.[13]

The woman's dress and appearance are clearly inappropriate to the circumstances, in a situation that emphasizes her contrived and vulgar look in contrast with the natural setting and the man's suntanned body.

Suitable for wearing over the costume and slipped off when the moment came to expose the body to sunlight and to public gaze, this simple and colorful garment offered protection to a class of women not accustomed to this unusual experience, whose culture made them suspicious of the enthusiasm for the health-giving effects of movement and direct contact with nature. Even though these had become arguments of fundamental importance in modernism, and despite the fact that the regime had made mass training in sport and hygiene a form of control over the body and a central plank of an ideology inspired by classical antiquity, a considerable part of the population, in particular the lower classes, continued to associate movement and the outdoor setting with exertion and labor. Women on beaches wearing light *vestagliette* unfastened at the front, seated on tiny stools under umbrellas, were displaying a determined resistance to revealing their bodies in public and, at the same time, the vestiges of a culture that considered repose and respite from nature a privileged condition.

The versatility of the *vestaglietta* or housedress meant that, starting out from the limited function of clothing for the seaside, it easily leant itself to a less specific use, as a simple summer dress. Over the course of time this led to a further expansion of the semantic content of the term, which was extended to denote new models of light open dresses.

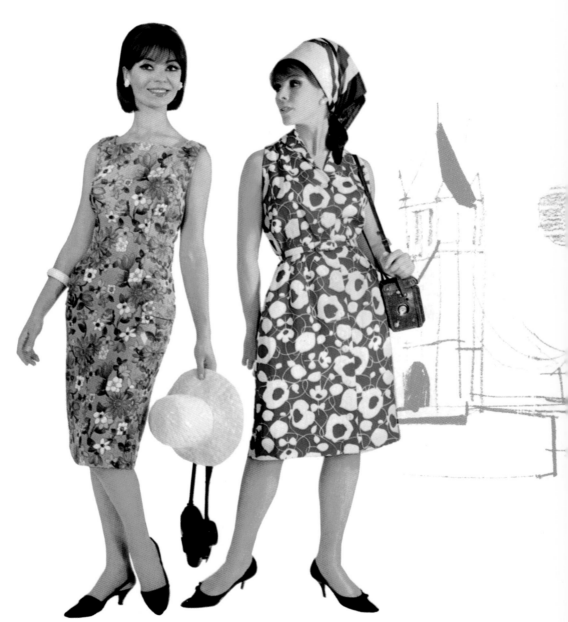

Vestebene models, mid-1960s.
Archivio Miroglio

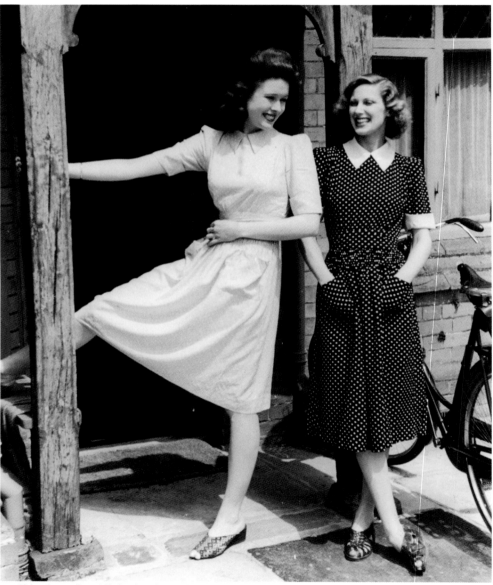

Utility dresses. From "Clothes for a Coupon Summer,"
in *Picture Post* no. 794, 1941. Getty Images Archive

The story of the manufacture of summer clothing, as Ivan Paris has observed, is a distinct and interesting chapter in the history of the women's clothing industry in Italy. The companies operating in this sector had found it possible to establish a relationship with a wider market, from the sixties onward, through precisely this type of production,[14] partly as a consequence of their moderate cost. In addition, the Italian cotton industry, along with the manufacturers of synthetic materials, had found a new use for printed fabrics in these products.

An emblematic case is that of the Miroglio industrial group, which in 1955 decided to enter the sector of women's wear with the brand "Vestebene," commencing with the mass production of housedresses.[15]

One of the distinctive features of the housedress is the decoration of its fabrics: the typical patterns are made up of tiny motifs, often printed on a dark ground. These motifs have multiplied over time, giving rise to an extraordinary range of designs and colors. It is a family of patterns that had proved an enormous success in the mid-19th century, when technological innovations in textile printing had permitted the intensive and low-cost production of decorated fabrics. It was at that moment in history and in the Anglo-Saxon culture in particular that the custom of using miniature floral patterns for clothing to be worn at home took root. These were printed, especially when intended for garments for elderly women, on fabrics with a dark ground. This was a code that lasted for a long time, as is apparent from the caption accompanying the drawing of a dress in a 1938 issue of *La Moda Illustrata*, where it is stated that "minute decorations on a dark ground are suited to plump ladies and elderly ladies."[16]

The significance of modesty, economy and even affection that Roland Barthes associates with the term *petit*, "small, little," at the connotative level seems to correspond perfectly with that of the miniature motif in the graphic language of decoration.[17] The functional aspects of the size of the pattern, such as those of masking ample forms and hiding stains, represent, in the words of Barthes

again, the "prudence of the real" which saves the choice of decoration from the accusation of frivolity.

From the technical viewpoint, in addition, it should be pointed out that the minute size of the pattern and its distribution over the entire surface make the fabric particularly suited to the making of clothes at home, as it is not necessary to pay special attention to getting the elements of the decoration to coincide when the various parts of the garment are sewn together. This is one of the reasons why, during the years of the Second World War, such fabrics were utilized for the production of so-called utility dresses in Britain, as part of the overall program of restrictions on the use of goods introduced by the British government in 1941. The plan entailed the rationing of cloth and the imposition of precise rules in the manufacture of dress models in order to limit the consumption of material. So the garments had to be simplified, among other things by reducing the number of pleats, pockets and buttons, and one of the measures adopted to avoid the waste of material was that of using fabrics with minute decorations. On the other hand the discreet colors and designs that characterized the production of calicoes, cheap cotton fabrics that were covered with patterns made up of myriads of closely packed rosebuds and other plant motifs made it easy to satisfy the desire for decoration in clothing: samples of fabrics with small designs filled many pattern books of the British, French and Italian industries in the 19th century, a mark of the diffusion of a kind of decoration whose tradition has persisted, although with diminishing popularity, until the present day. During a period in which the fabric constituted the main cost in the making of a garment, the appearance of an economic material and a system of printing that made it possible to introduce new and varied decorations with greater frequency represented a sort of "McLuhanian" revolution in fashion.

The decorative richness of printed fabrics, when combined with textiles of low value, is frequently associated with a connotation of inferiority, linked with poor and undeveloped cultures. This is an aspect of decorative textile culture that was addressed explicitly in a study carried out by the Centro Design Montefibre in the seventies,

in which this kind of pattern was defined, in a metonymic association between product and sales outlet, as *merceria* or "haberdashery"[18]: in fact it was and still is easier to find these fabrics or the clothes made from them in the notions stores of rural areas and the suburbs. The decision, made under those circumstances, to insert these types of popular decoration in a volume devoted to textile culture seems to have stemmed in part from the desire to propose and investigate an anthropological dimension of that culture, characterized by a high degree of expressiveness and decorative superfluity, in antithesis to the modernist tendency to reject ornamentation.

Le Corbusier also alluded to a relationship between decoration and backwardness when, in a passage of *L'Art decoratif d'aujourd'hui,* a printed fabric is presented as the emblem of the superficial femininity of a pretty young woman of the lower classes:

Take some plain calico and soak it in color; the printing machine will instantly cover it in the most fashionable patterns (for example, copies of Spanish mantillas, Bulgarian embroidery, Persian silks, etc.) and without much expense one can double the sale price. I quite agree that can be as charming, as gay, and as shop-girl as you could want, and I would want that to continue. What would spring be without it![19]

Le Corbusier seems to appreciate the flowered cotton of the shop-girl's dress as a joyful manifestation of the spring: but, for the author, the decoration of the clothing worn by the young woman is acceptable only if it occurs in a context that does not reproduce and multiply such a frenzy of ornamentation. The text goes on to describe decoration as if it were a virus, a way of masking defects, of concealing the essence of truth of the object that is visible only in the hygienic purity of its surface. It is only to "the healthy gaiety of the shop girl in her flowered-patterned cretonne dress," to the "pretty little shop-girl shepherdess in her flowered-patterned cretonne dress," that this moment of ingenuous and joyous excess is conceded. The passion for cheap stuff, in this case, seems to constitute a yielding of an erotic character to the popular

manifestation of instinct and desire in contrast to the pleasure of the strict control proper "to the well-made, clear-cut and clean, pure and healthy luxury article, whose nudity reveals its excellent workmanship."[20]

In Le Corbusier's view colors and decorative patterns remain acceptable, on a woman, only on condition that they are seen in contrast to modernist white walls and surfaces: surfaces that Mark Wigley, in his *White Walls, Designer Dresses. The Fashioning of Modern Architecture*, defines as "masculine."[21] For the author, the degree of separation placed by Le Corbusier between the lower-class country girl and the modern woman is not so great as it might appear, and both cases are representative of the attempt to control the feminine, in an analogy with the attempt to control color in architecture.

The association of the shop girl with a dress of printed cotton is not coincidental: since the end of the 19th century cotton decorated with floral prints had become a material widely used for women's work clothes, a custom that was continued in the following century and kept alive by women of different social conditions. In general, the floral print was applied to fabrics used for cheap garments of a utilitarian character, as well as for summer clothing.

The great success of these cheap cotton garments commenced in the United States with the industrial production of readymade clothing, whose sale was particularly favored by the widespread distribution permitted by mail-order catalogues. The development of the transport and postal systems had contributed to the effectiveness of this method of buying and to the distribution of clothing along with a great variety of other goods. Between the end of the 19th century and the beginning of the 20th, with the introduction and improvement of the Rural Free Delivery service, journals and packages found it easy to reach destinations a long way from the major urban centers.

The catalogues of the big mail-order companies presented themselves, to use the words of Kirk Varnedoe, as "surrogates show windows" that brought into homes a wealth of images capable of stirring the imagination and rousing desires, page after page.[22] From

another point of view, the same catalogues are now an important iconographic source for forms of clothing adopted by a large number of people and poorly documented in the magazines. Skimming through their pages offers a sort of compendium of the evolution of the styles proposed by fashion, changes that were reflected, although with less emphasis and variety, in the more economic clothing aimed at working-class buyers: one of these catalogues, that of Sears, Roebuck and Co., which described itself as the "Cheapest Supply House on Earth," proposed mail-order purchasing as a way to save money and at the same time keep up with the latest fashions.

If in the United States the spread of the housedress was favored by the system of mail-order selling, in Italy other forms of distribution proved more effective. In our country the sale of fashion products by mail had already commenced between the end of the 19th century and the beginning of the 20th, in parallel with the development of transport and industrial growth: during that period numerous catalogues specializing in the clothing sector existed and there was no shortage in them, as a journalist of the time wrote of the Bocconi catalogue, of examples of "cheap models of clothing for modest women."[23] Over the course of the 20th century, however, this method of purchase did not develop greatly in Italy, while hawkers and markets, in big cities as well as small towns, constituted a distribution channel that has never ceased to attract a large and composite group of consumers, made up largely of people with limited funds. Even today itinerant peddlers are able to hold their own in competition with large-scale retail trade, relying not only on their all-pervading presence, but also on their direct relationship with a public that wants to see and touch the object before buying it. Indeed it can be argued that it is precisely this propensity on the part of buyers to rely on touch, which among other things has induced some manufacturers to leave the wrapping of transparent plastic open at one end to give their customers access to the fabric, that explains in part the limited success of the mail-order selling of clothing in Italy.

And so, in addition to production in the home and by seamstresses, practices which continued even after the end of the Second World War, it has been chiefly sales at market stalls and in notion stores that have made the housedress a popular garment. Through wholesalers of fabrics and then suppliers of haberdashery products, the industrial production of housedresses found an adequate system of distribution in Italy, and one that reflected its character as clothing for the home, for private and family life: when they are not available on market stalls, in fact, these garments can always be found in the notion stores that still survive in provincial towns, in the midst of household linen, underwear and the odd item of casual wear. And among some women living in these towns or in rural areas, the habit persists of buying the same number of housedresses from these stores as there are days in the week, so that they can put a clean one on every day: the marking of time within the home is regulated by the change of clothing, even though it is always in the same style. It is a custom that reinforces the housedress's character as a uniform and reflects the establishment, with modernity, of new standards of hygiene for the person and the home; and it is also one of the reasons why it is still made chiefly out of cotton, a material that makes it suitable for frequent washing and that further underlines the affinity of this garment with the overall.

Cotton was, and remains, especially in Italy, the preferred material for housedresses and so it is no accident that their production was initially closely linked to the areas in which cotton mills were located, and in particular the textile district north of Milan, where some of the principal manufacturers like Aertre of Olgiate Olona are still based. The typology of the models present in recent catalogues maintains a precise recognizability with respect to traditional styles, and at the same time is adapted to the seasonal character of contemporary fashion through the creation of "collections" that introduce new details and variations into the basic models. The only important exception to this continuity occurred in the sixties with the introduction, alongside traditional housedresses, of a loose jacket or blouse to be worn with pants, after the use of the latter by women

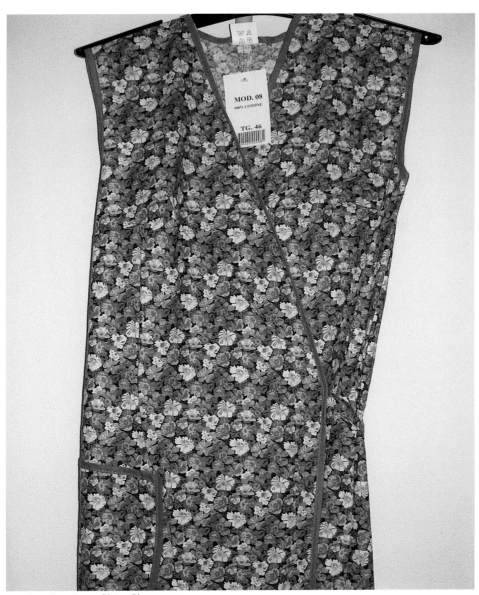

Housedress. Aertre, Olgiate Olona.
Archivio Aertre

in Italy had finally become established. Apart from its concentration in the traditional textile-manufacturing areas, the production of housedresses spread to other parts of Italy in the 1960s and 1970s, but in more recent years changing customs and the gradual fading of interest in this garment have induced some of the companies to eliminate it from their range, as in the case of the manufacturer Siggi at San Vito di Leguzzano in the Vicenza region, sometimes under the pressure of competition from other countries and China in particular. Even in many of the companies of the Paduan region, which had specialized in the past in the production of this type of clothing, the emphasis has now shifted principally to the manufacture of frocks and work clothes.

The fact is that housedresses have much in common with the modern overall: they are shirtwaists that sometimes, in the most simplified versions, do not even have a collar. But this trend toward a standardization and simplification of forms is opposed by a desire to preserve certain details that take away from the garment the character of a work frock: the colored trimming, the decorated collar and above all the printed fabrics that contrast with the uniformity and solid color of the factory overall.

NOTES

[1] Bruno Migliorini, *Storia della lingua italiana.* Florence: Sansoni, 1961, p. 726.
[2] Carlo Battisti and Giovanni Alessio, *Dizionario etimologico italiano.* Florence: Barbéra, 1955, 5 vols.
[3] Policarpo Petrocchi, *Novo dizionario universale della lingua italiana.* Milan: F.lli Treves, 1931, 2 vols.
[4] Cesare Meano, *Commentario dizionario italiano della moda.* Turin: Ente Nazionale della Moda, 1936.
[5] "a light housedress of a very pale blue color." Luigi Pirandello, "O di uno o di nessuno," in id., *Maschere nude,* ed. by Italo Borzi and Maria Argenziano. Rome: Newton Compton, 1993 [orig. ed. 1929], p. 990.
[6] *Vocabolario della Lingua italiana.* Rome: Istituto dell'Enciclopedia Italiana, 1994, 4 vols.
[7] David Forgacs and Stephen Gundle, *Mass Culture and Italian Society from Fascism to the Cold War from Fascism to the Cold War* Bloomington: Indiana University Press, 2008. The passage has been translated from the Italian edition, *Cultura di massa e società italiana 1936-1954.* Bologna: Il Mulino, 2007, p. 131.

[8] Rosita Levi Pisetzky, "Storia del costume in Italia," in *Enciclopedia della moda*. Roma: Istituto dell'Enciclopedia italiana Giovanni Treccani, 2005 [orig. ed. 1964-69], 3 vols., p. 489.

[9] Cesare Meano, op. cit., p. 355.

[10] Ibid.

[11] Eugenia Paulicelli, *Fashion under Fascism. Beyond the Black Skirt*. Oxford-New York: Berg, 2004, p. 80. More in general, the book contains a careful analysis of Meano's text in relation to the Fascist attempt to construct a national identity through fashion.

[12] Carlo Cassola, *Un cuore arido*. Turin: Einaudi, 1961, p. 154.

[13] Cesare Pavese, *La spiaggia*. Turin: Einaudi, 1968 [orig. ed. 1941], pp. 39-40.

[14] Ivan Paris, *Oggetti cuciti. L'abbigliamento pronto in Italia dal primo dopoguerra agli anni Settanta*. Milan: Franco Angeli, 2006, p. 144.

[15] Alberto Mazzuca, "Alba veste bene," in *Il Sole 24 ore*, December 15, 1985.

[16] *La Moda Illustrata*, February 20, 1938, XVI, yr. 53, no. 8.

[17] Roland Barthes, *Système de la mode*. Paris: Seuil, 1957. Eng. ed: *The Fashion System*, trans. by Matthew Ward and Richard Howard. Berkeley: University of California Press, 1990.

[18] Centro Design Montefibre, "Introduzione e iconografia," in *Decorattivo 1975*. Milan: Montefibre, 1975.

[19] Le Corbusier, *L'Art decoratif d'aujourd'hui*. Paris: Les Editions G. Crés et C.ie, 1925, p. 90.

[20] Ibid.

[21] Mark Wigley, *White Walls, Designer Dresses. The Fashioning of Modern Architecture*. Cambridge, Mass.: MIT Press, 2001, p. 278.

[22] Kirk Varnedoe, "Advertising," in *High and Low. Modern Art and Popular Cultures*, ed. by Kirk Varnedoe and Adam Gopnick. New York, Museum of Modern Art: 1990, p. 254.

[23] Introduction to the album of latest fashions for the summer of 1889 produced by the "Alle Città d'Italia" department store, cited in Maria Catricalà, "Il catalogo Bocconi: vestirsi per corrispondenza a fine '800," in *Per filo e per segno. Scrittura di moda di ieri e di oggi*, ed. by Maria Catricalà. Rubbettino: Soveria Manelli, 2004, p. 88.

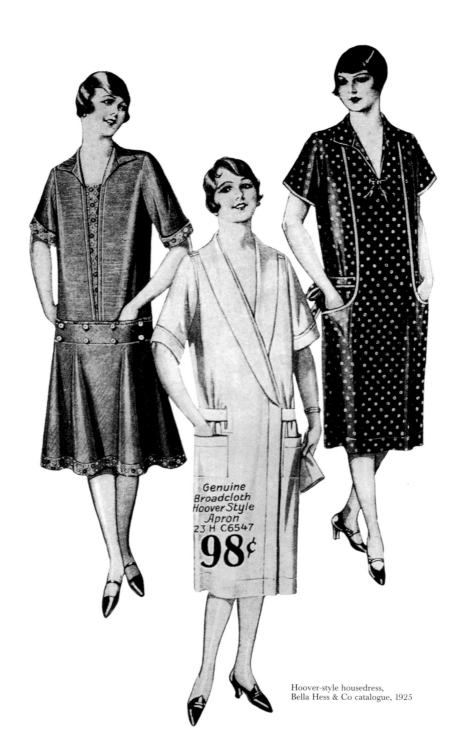

Genuine
Broadcloth
Hoover Style
Apron
23 H C6547
98¢

Hoover-style housedress,
Bella Hess & Co catalogue, 1925

A Uniform for the Home

A historical reconstruction of the form and the social and cultural implications of the housedress cannot ignore its links with the emergence of a debate and an ideology concerning the organization of the home and domestic life and the role that the women were expected to play in them.

The spread of a new kind of housedress was favored by, among other things, the programs of rationalization of the home environment and housework that had been the subject of discussion and propaganda since the beginning of the 20th century, especially in the English-speaking world: when the article "The New Housekeeping. Efficiency Studies in Home Management" was published in the *Ladies' Home Journal* in 1912, it was illustrated with a photograph of the author Christine Frederick at work in a kitchen organized in a scientific way, wearing a white gown similar to the ones used in hospitals. The image of the kitchen as the woman's temple, a place in which all the surfaces and objects had to be white and everything had to have the "scientific cleanliness of a surgery," had already been proposed ten years earlier by Isabel McDougall, in un article that had appeared in the magazine *The House Beautiful* and was entitled "An Ideal Kitchen."[1]

With the outbreak of the First World War, these themes found an application through the initiatives of the Food Administration, an American organization that, in the context of a plan to involve civilians in the supply of food for the troops, had proposed the "militarization" of housework and the consequent adoption of a suitable uniform, which was described in a magazine of the time as follows:

The Food Administration uniform of service [...] is such a practical, trim, and attractive house dress that it is sure to be popular. [...] One of the best points about the costume is that it is very easy to launder. [...] The dress itself is in one piece and opens out flat so that it can be ironed about as easily as a small sheet. The housewife slips into it as she would slip into a coat.[2]

The structure of this overall is very similar to that of the wraparound version of the housedress: open at the front, it is closed by overlapping the two ends that extend to form two strips of fabric at the level of the waist and fixing them at the back with a button. The garment could be purchased readymade or as a kit that included the fabric, the paper pattern and all the accessories needed for it to be made at home. One innovative aspect with respect to the traditional indoor wear of the time was the opening at the front, which made it simpler to put on and take off the garment. In addition to this variation in form, however, what distinguished it was the new character of a uniform. The circumstance of the war and the desire to involve the female population in the war effort were the main reasons for the invention of this uniform, but its significance is only fully comprehensible if it is seen as part of the overall plan to bring about a modernization of the domestic sphere.

The aim of transforming the banal housedress into a uniform contained a further element of innovation, consisting in the attempt to confer dignity, social status and a sense of solidarity on housewives, thereby enhancing the quality of their work and their civil participation. Through the badge of the Food Administration and the cap, which was modeled on the contemporary beret of the uniform of the Russian army, even housewives would be able to feel they were part of a body acting in the service of society. In June 1917 an announcement was published in the *New York Times* aimed at rural housewives, inviting those who had signed up with the Food Administration to wear the uniform as a symbol of their affiliation to that institution.[3]

The uniform came to be known as the Hoover apron, named after Herbert Hoover, director of the Food Administration from 1917, the

year of the United States entry into the war against Germany. The
objective, as has already been pointed out, was to organize and
implement a plan to encourage the voluntary cooperation of civilians
in the supply of food for the military. "Food Will Win the War!" was
the slogan of the propaganda campaign organized for this scheme,
which set out to involve the entire American population and, in the
domestic sphere, to persuade women to favor the use of certain
products, to conserve foodstuffs and to eliminate waste.

In addition to the propaganda campaign, the mobilization and
education of the population, and women in particular, were
indispensable if the objectives were to be attained. The contribution
made by the experts in domestic science called on to participate in
the Food Administration's scheme was, as Joan Sullivan argues,[4]
crucial in communicating the principles of the rationalization of
housework, reinforcing the perception of the Hoover apron as a
garment that symbolized modern American housekeeping.

Since the beginning of the 20th century, a new model of female
schooling had been establishing itself in the United States, one in
which ample space was given to an idea of home economics that
turned on a management of domestic space according to methods
derived from the scientific organization of industrial labor. The
reform of the organization of housekeeping was widely promoted,
especially in the English-speaking world, through women's
magazines and books aimed at a female readership that had to cope
with a new conception of life and work in the home. Constance Peel,
who was the editor of the section of the magazine *Queen* devoted to
the home and the women's column of the *Daily Mail*, wrote many
books, commencing with the famous *The Labour Saving House*, which
proposed ways of transforming and rationalizing work spaces in the
home: the principal factor that made these changes necessary, in the
view of the British journalist, lay in the altered economic and social
conditions of the middle class in the early decades of the 20th
century. The work that had previously been done by domestic
servants had become the responsibility of the mistress of the house:
the increasing numbers of woman employed in industry, especially

during the First World War, the rise in wages and the improvement in the level of workers' education had, in fact, made it considerably more difficult for the middle class to hire servants.

As early as the first half of the 19th century Catharine Beecher, author of *A Treatise on Domestic Economy* in 1841, had focused her attention on the hygienic aspects of the body and the home, which she regarded as a crucial place for the well-being of American society and a sphere that fell within the competence of women. In Beecher's writings relatively little space is devoted to clothing, although she did not fail to suggest the most respectable and appropriate way of dressing for the pupils of girl's schools, in an attempt to define a model of clothing consonant with the new form of housekeeping:

As to dress, and appearance, if neat and convenient accommodations are furnished, there is no occasion for the exposures which demand shabby dresses. A dark calico, genteelly made, with an oiled-silk apron, and wide cuffs of the same material, secures both good looks and good service.[5]

But it was above all with the publication of the works of Christine Frederick that a genuine reform of the domestic environment and work was promoted, in Europe as well as in the United States. Her volume of 1915, *Household Engineering*, has been described as the watershed after which "the home becomes a domestic enterprise, the housewife, who wears a uniform instead of the usual shabby dress, is a manager to all intents and purposes, the kitchen is a *laboratorium* and the activities are defined as household engineering."[6]

The fame and reputation of the American author were propagated internationally thanks to the translation of her publications and the spread of her theories through the mass media: in Italy, *The New Housekeeping: Efficiency Studies in Home Management* was published in 1927 as *La donna e la casa. Il taylorismo nella vita domestica* ("The Woman and the Home. Taylorism in Domestic Life"). During that period she was invited to give a large number of lectures in various European nations: in the fall of 1927 she took part in the Exposition

of the House in Paris and the Congress of Domestic Economy in Rome, where she met Benito Mussolini.

Among Christine Frederick's contacts in Italy it is worth mentioning in particular Maria Diez Gasca, editor of *Casa e lavoro*, a monthly magazine devoted to questions of domestic science that had been founded in 1929 by the ENIOS, the Fascist public body for the promotion of the scientific organization of labor. In 1933 Diez Gasca, who was an active supporter of the introduction of the rationalization of housework in Italy, had translated Christine Frederick's book, *Household Engeneering: Scientific Management in the Home* published under the title *La casa moderna. Come risparmiare tempo, fatica, denaro* ("The Modern House. How to Save Time, Effort and Money"). Lidia Morelli, who had written about architecture and the organization of the kitchen with a view to improving its efficiency, was also influenced by American research in this sector and was one of the advocates of a policy for domestic rationalization in Italy: in her ideal vision of a kitchen functioning with the efficiency and cleanliness of a hospital, the United States was the example to be followed. But, according to Victoria de Grazia, the project of reform of the home on the American model had little impact in Fascist Italy. The great difference between the lives of Italian and American families – in terms of income, living conditions and lifestyle – was, for the author, the prime reason for the impracticability of such a project in the Italian context. Secondly, in our country one section of the women who migrated from the countryside to the city ended up increasing the availability of servants to middle-class families, the opposite trend to what had happened in Britain and the United States.[7] In essence, the rationalization of work within the home was not a subject that attracted particular interest in Italy, in part because the principles of Taylorism had not yet found full application even in the country's factories, and in part because the living conditions of the majority of the population were very far from meeting the requirements for such a reorganization.

So while it is evident that in the period between the 1920s and 1930s

the possibility of a transformation of the domestic environment based on Taylor's principles of scientific management was fairly remote in Italy, it is still possible to identify a tendency in the same years to steer the impulses toward rationalization in the direction of a dimension of modernity, a tendency that found expression in the arena of the conduct and dress of women inside the home. Signs of this trend can be found, for instance, in the layout and contents of *La Moda Illustrata*, a weekly magazine for families published in Milan by Sonzogno and aimed principally at women of the middle class: the magazine provided suggestions and hints on how to keep up with fashion and also offered paper patterns to its readers from which they could make clothes for themselves. An article devoted to indoor wear, published in 1923, is particularly significant in the way that it reflects the tendency towards the definition of a modern style of dress, suited to the new rhythms of work and the new standards of hygiene.

[...] In the daily course of her active life the mother of a family has no time to look for elegance in the clothes she wears in the morning hours, when she has to get her husband ready for the office and her children ready for school, give the necessary orders, make sure they are carried out and often, having been obliged to reduce (and how!) the number of domestics, take on some of the tasks herself.
No, seductive, sumptuous lace bonnets and suggestive robes are not made for her. As soon as she gets out of bed she dons her dressing gown, does her hair in a very perfunctory manner and covers it, to keep it tidy and protect it from the dust while she does the household chores, with a cloth cap whose exemplarity is a guarantee of cleanliness.
As soon as her husband and children have left, she slips a loose and enveloping smock (it would be more appropriate to call it a nurse's overall) over her housedress to tidy up her own room and that of her children. Perhaps she also gets ready to go out to do the shopping and the like, either to make up for the inexperience of a still young maid or for reasons of economy, for it is one thing to tell someone what to purchase and quite another to do it yourself. Faced with the irregularities in the arrival of provisions and the disconcerting swings in their prices, a housewife can at will change her purchases on the spot, i.e. in the market and at the stores, while a domestic cannot or does not know how to do so with discretion and

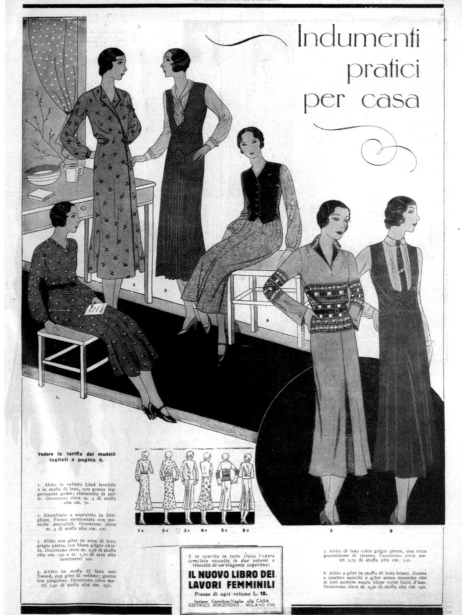

"Indumenti pratici for la casa"
("Practical Garments for the Home"),
in *La Moda Illustrata*, April 1934

prudence [...] In her robe of *nubiana* (always clean because *nubiana* is a washable fabric), the mistress of the house has lunch with her family, and then dresses in the manner she did not have the leisure to do before, either because, returning from the market or the shops, she had to help the maid in the kitchen or attend to some urgent housework. So many chores, in fact, are lying in wait, at every moment, for capable and active ladies of the house whose economic situation is modest![8]

What emerges from this lively domestic picture is the description of a bourgeois setting in which the woman of the house behaves and dresses in a way suited to the new dimension of modern life, in which there is no opportunity to put on "suggestive robes" and sumptuous lace bonnets: an observation relating to the contrast between modern dress and the frivolous garments of the past that can also be found in the already cited comments on the *vestaglia* in Meano's *Commentario*. The allusion to her responsibilities in the management of the domestic staff and the family economy lends a character of respectability to the whole and underlines the practical and modern, and above all not menial, nature of the garment described. What is outlined is the figure of a skillful and prudent administrator of the family's resources and an attentive follower of the rules of modern living that demand hygiene and decorum: the reference to the nurse's overall is a mark of this new mission and the "professional" rigor that is now attached to the traditional image of the loving and maternal woman. It may be significant from this point of view that, in another issue of *La Moda Illustrata* published in 1923, there is an illustration of a housedress that closely resembles the model of the American uniform. On the same page, where a range of clothes designed for the different engagements in a modern woman's day, from the "practical overall" to "elegant evening dresses," is presented, there is another model of a housedress in a flower-patterned fabric, fastened like a dressing gown with a wide belt. In general the magazine devoted a lot of space to clothes to be worn in the home, which were often presented as simplified versions of fashionable garments, made out of cheaper materials. Over the

course of the thirties, the models of housedress proposed by *La Moda Illustrata* tended to reflect the taste in clothing of young women, of the shop girls and secretaries who were the protagonists of the "white telephones" movies, and the presentation of buttoned or wraparound housedresses, in many cases fitted with detachable sleeves, followed this trend as well. At the same time, it is also possible to discern a link with the contents of contemporary American clothing catalogues, both in the similarity of the models of housedresses presented and for the fact that some of descriptions contain an unusual reference to gingham, an English term indicating a checked fabric traditionally used as an alternative to floral materials for housedresses and aprons.

NOTES
[1] Isabel McDougall, "An Ideal Kitchen," in *The House Beautiful*, 13, December 1902, pp. 27-32, cited in Joan L. Sullivan, "In Pursuit of Legitimacy: Home Economists and the Hoover Apron in World War I," in *Dress. The Journal of the Costume Society of America*, vol. 26, 1999, pp. 33.
[2] Mildred Maddocks, "Good Housekeeping Institute," in *Good Housekeeping*, September 1917, p. 74.
[3] "Plan for Women's Aid," in *The New York Times*, 22 June 1917, p. 3.
[4] Joan L. Sullivan, "In Pursuit of Legitimacy ...," cit., p. 31.
[5] Catharine Esther Beecher, *A Treatise on Domestic Economy: For the Use of Young Ladies at Home, and at School.* New York: Harper & Brothers, 1845, p. 56.
[6] Giovanna Brancato and Lorenza Medici, "La stanza delle sculture radiose. Lineamenti di storia dello spazio cucina," in Gisella Bassanini (ed.), *Architetture del quotidiano.* Naples: Liguori, 1995, pp. 17-118.
[7] Victoria de Grazia, *Le donne nel regime fascista.* Venice: Marsilio, 1993.
[8] "Abiti da casa," in *La Moda Illustrata*, no. 7, yr. XXXVIII, Sunday, February 18, 1923, p. 51.

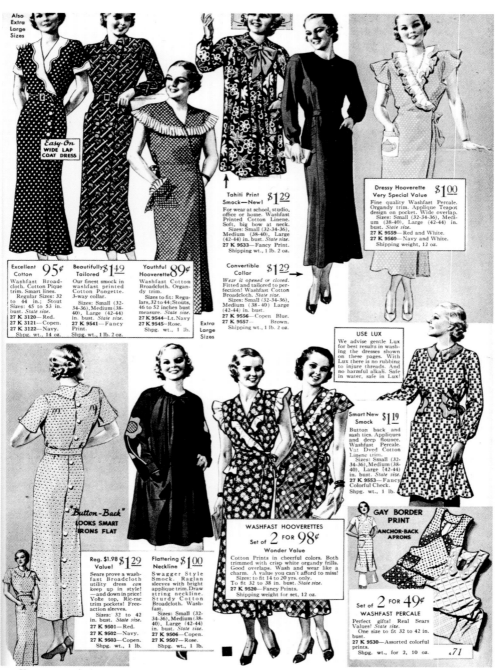

Also
Extra
Large
Sizes

Easy-On
WIDE LAP
COAT DRESS

**Excellent
Cotton** 95¢

Washfast Broad-
cloth. Cotton Pique
trim. Smart lines.
Regular Sizes: 32
to 44 in.; Stout
Sizes: 45 to 53 in.
bust. *State size.*
27 K 3120—Red.
27 K 3121—Copen.
27 K 3122—Navy.
Shpg. wt., 14 oz.

**Beautifully
Tailored** $1.49

Our finest smock in
washfast printed
Cotton Pongette.
3-way collar.
Sizes: Small (32-
34-36), Medium (38-
40), Large (42-44)
in. bust. *State size.*
27 K 9541—Fancy
Print.
Shpg. wt., 1 lb. 2 oz.

**Youthful
Hooverette** 89¢

Washfast Cotton
Broadcloth. Organ-
dy trim.
Sizes to fit: Regu-
lars, 32 to 44; Stouts,
46 to 52 inches bust
measure. *State size.*
27 K 9544—Lt. Navy
27 K 9545—Rose.
Shpg. wt., 1 lb.

Extra
Large
Sizes

**Tahiti Print
Smock—New!** $1.29

For wear at school, studio,
office or home. Washfast
Printed Cotton Linene.
Soft, big bow at neck.
Sizes: Small (32-34-36),
Medium (38-40), Large
(42-44) in. bust. *State size.*
27 K 9533—Fancy Print.
Shipping wt., 1 lb. 2 oz.

**Convertible
Collar** $1.29

Wear it opened or closed.
Fitted and tailored to per-
fection! Washfast Cotton
Broadcloth. *State size.*
Sizes: Small (32-34-36),
Medium (38-40) Large
(42-44) in. bust.
27 K 9556—Copen Blue.
27 K 9557—Brown.
Shipping wt., 1 lb. 2 oz.

**Dressy Hooverette
Very Special Value** $1.00

Fine quality Washfast Percale.
Organdy trim. Applique Teapot
design on pocket. Wide overlap.
Sizes: Small (32-34-36), Medi-
um (38-40), Large (42-44) in.
bust. *State size.*
27 K 9559—Red and White.
27 K 9560—Navy and White.
Shipping weight, 12 oz.

USE LUX

We advise gentle Lux
for best results in wash-
ing the dresses shown
on these pages. With
Lux there is no rubbing
to injure threads. And
no harmful alkali. Safe
in water, safe in Lux!

**Smart New
Smock** $1.19

Button back and
sash ties. Appliques
and deep flounce.
Washfast Percale.
Vat Dyed Cotton
Linene trim.
Sizes: Small (32-
34-36), Medium (38-
40), Large (42-44)
in. bust. *State size.*
27 K 9553—Fancy
Colorful Check.
Shpg. wt., 1 lb.

"Button-Back"
LOOKS SMART
IRONS FLAT

**Reg. $1.98
Value!** $1.29

Sears prove a wash-
fast Broadcloth
utility dress *can*
keep up in style!
—and down in price!
Yoke top, Ric-rac
trim pockets! Free-
action sleeves.
Sizes: 32 to 42
in. bust. *State size.*
27 K 9501—Red.
27 K 9502—Navy.
27 K 9503—Copen.
Shpg. wt., 1 lb.

**Flattering
Neckline** $1.00

Swagger Style
Smock. Raglan
sleeves with bright
applique trim. Draw
string neckline.
Sturdy Cotton
Broadcloth. Wash-
fast.
Sizes: Small (32-
34-36), Medium (38-
40), Large (42-44)
in. bust. *State size.*
27 K 9506—Copen.
27 K 9507—Rose.
Shpg. wt., 1 lb.

WASHFAST HOOVERETTES
Set of 2 FOR 98¢
Wonder Value

Cotton Prints in cheerful colors. Both
trimmed with crisp white organdy frills.
Good overlaps. Wash and wear like a
charm. A value you can't afford to miss!
Sizes: to fit 14 to 20 yrs. only.
To fit 32 to 38 in. bust. *State size.*
27 K 9520—Fancy Prints.
Shipping weight for set, 12 oz.

**GAY BORDER
PRINT**
**ANCHOR-BACK
APRONS**

Set of 2 FOR 49¢
WASHFAST PERCALE

Perfect gifts! Real Sears
Values! *State size.*
One size to fit 32 to 42 in.
bust.
27 K 9530—Assorted colorful
prints.
Shpg. wt., for 2, 10 oz.

71

Hooverettes and other housedresses,
Sears catalogue, 1935

From the Uniform to the Dress

The hypothesis of a domestic uniform, as has been pointed out, found concrete expression in the United States at the time of the First World War, when there was a convergence between the mass recruitment of women on the "home front" and the proposals for rational transformation of the domestic environment and housework. Once the war was over, the Hoover apron lost the look of a uniform, turning into an ordinary house frock and then becoming for many American women, during the period of the Great Depression, the only garment available. Under these circumstances, distributed by the organizations of public assistance to the families of the unemployed along with other basic necessities, it lost its original connotation of efficiency and turned into a mark of poverty.

Over the following years, one garment that retained the structural principle of the old uniform, but adapted to the fashion and taste of the thirties, was given the name of Hooverette, again with reference to the politician who had in the meantime become president of the United States. In the illustrations of the time its form perfectly echoed the wraparound model of the housedress, from which it was distinguished solely by the presence of applications and by decorative details, such as gathered borders in contrasting colors or materials or pieces of lace. In the Sears catalogues of those years we can find various examples of the Hooverette and similar models, one of which was marketed under the name of Searsette and described as "the perfect house frock." In one of these images, mother and daughter are wearing the same model: almost an allegorical representation of the possible handing down of a role through

clothing, and at the same time the proposal, through its decorative harmony, of an ideal of comfort and domestic "intimacy."

As early as the beginning of the 20th century, as was stated earlier, the mass production of low-cost garments, distributed by mail order or sold in department stores, had become a distinctive feature of the American clothing industry: an aspect that would lead the Italian journalist Colette Rosselli, in the fifties, to declare that "ladies and girls will buy the readymade clothing" that can be found in stores where "charming dresses can be bought for a few dollars."[1]

Among the numerous companies that produced this kind of women's wear industrially and that at the same time made overall and work clothes, were Barmon Brothers of Buffalo and Biberman Brothers of Philadelphia, manufacturers cited in a handbook for vendors of aprons, housedresses and uniforms published in 1925.[2] One very popular brand of indoor wear and clothing produced on an industrial scale in general was that of the Donnelly Garment Company: founded in 1916, it quickly became one of the most important manufacturers in the sector, selling over a million and a half articles in 1931. A recurrent style among the clothes made by Donnelly was the shirtdress, a model that over the following decades was to become the icon of the American housewife and that was characterized by several formal and connotative traits that it shared with both the overall and the button-up version of the housedress. The interest in the man's shirt as an explicit model for a woman's dress is apparent, for example, in *Patterns for Blouses and Dresses*, published in 1917 by the Women's Institute of Domestic Arts and Sciences, in which a "mannish-shirtwaist" is proposed and described as a "garment so designed as to follow practically the same lines as those of a man's negligee shirt."[3] In another volume of models produced by the same institute, published the previous year, a similar dress was presented as a simple and practical item that was also suitable for school or work thanks to the advantages offered by its clean simplicity and dignified elegance.

So in the definition of an appropriate form for a woman's work garment one of the necessary steps seems to have been that of

borrowing from the male wardrobe. From the end of the 19th century onward, with the need to insert women into a dimension of professional competence and efficiency, men's clothing would be, as Anne Hollander argues, the only kind that was capable of expressing the idea of the "man's body as a visibly working, self-aware and unified instrument."[4]

Moreover, it was precisely to a net distinction between the female and male universes in terms of productivity that Veblen had referred in his famous text on the behavior of the leisure class, when he contrasted the conspicuous waste represented women's fashion with men's preference for efficient work and disgust with frivolity.[5]

It is no coincidence, therefore, that the image of efficiency should have been conveyed through traditionally masculine elements and that the cut of the shirt constituted the fundamental reference for many versions of professional uniforms, from the simple overall worn by men and women in factories, stores and workshops to the more characteristic models of female uniforms. At the same time it formed the basis of a woman's garment, the shirtwaist, whose popularity has proved enduring, partly as a result of its adaptation to changing fashions.

During the Second World War the shirtwaist had shown itself to be particularly suitable as a prototype for a style of utility dress, owing to its essential lines – close in some ways to the severity of military uniforms – and the small amount of material required for its manufacture. Reproduced frequently in all the fashion magazines in the forties, the shirtdress remained popular in the following decade in a new version that became the costume preferred by the media to represent women in the home: its image is still associated today with the housewife as she was presented in that period in American advertising, with the model of middle-class life in the suburbs of American cities and with the representation of new technological appliances for use in the home.

Against this background we see a proliferation of new models of simple women's garments that sought to marry the practical characteristics of overall and housedresses with the qualities of

fashionable clothing, with the aim of guaranteeing the outfits of housewives a level of respectability and elegance appropriate to the change in social relations and the new lifestyles.

A fitting example of this transition is provided by the swirl.

In 1944 the L. Nachman and Son Company had patented a new type of garment, defined as a "wrap-around apron" and marketed under the brand Swirl: it had the typical appearance of a housedress, fastened by crossing two strips of cloth at the front.

The American company went on to create several different models out of this first type of wrap dress, with the aim of offering a greater variety of styles, suited to the changes in women's daily lives. In the fifties the overlap of the strips of cloth was shifted to the back of the garment, an alteration that was not just formal but rendered its connotation as clothing to be worn in the home less evident. The advertisements in women's magazines stressed the practicality and versatility of Swirl dresses: a page in the *Mademoiselle* magazine of 1951 showed a sequence of pictures of a model who, after slipping on the dress in a moment and giving her hair a quick brush, sits down to read a book and has a conversation on the telephone. The adaptability of the garment to different activities, none of them connected with housework, coincided with the new image of a dynamic and fashionable housewife: one of the advertising slogans for Swirl was "your wrap 'n' tie fashion."

In the forties, the need for a renewal of the everyday image of women was something that was felt, in the United States, in the institutional world of fashion and designers too. This is demonstrated by, among other things, the project that led to the production and success of the popover dress. The war also had an influence on the aesthetic aims of the fashion magazines, inducing their editors to confront the everyday aspects of women's work in the home and the need to keep the activity of the manufacturers going despite the straitened circumstances of those years. In 1942, moreover, the War Production Board of the United States had introduced a form of rationing that covered even textiles employed in the clothing industry, limiting the use of some fibers and laying down strict rules

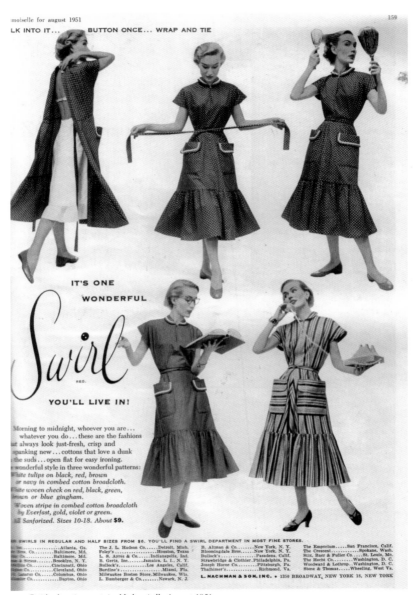

Swirl advertisement, in *Mademoiselle*, August 1951.
Courtesy Lizzie Bramlett

specifying the size, cuts and fabrics that designers could make use of in their models. It was under these conditions that Diana Vreeland and Carmel Snow, editor of the fashion pages and managing director of *Harper's Bazaar* respectively, turned to Claire McCardell and asked her to create a garment for women who "faced with the facts of life"[6] and personally took charge of running the household.

The consonance between the needs of the moment and the American designer's penchant for essentiality and functionalism led to the creation, in 1942, of the popover, a reworking of the wrap dress in which the overlapping part of the two frontal strips of the garment was closed on one side with buttons. A detail that links this, like many of McCardell's other models, to simpler housedresses is the decision to use buttons and ties instead of zips, especially at the back. As she put it, "a woman may live alone and like it, but may soon come to regret it if you wrench your arm trying to zip a back zipper into place."[7]

The illustration of the model designed by McCardell shows the version in denim, with a large pocket on one side; a quilted mitten in the same fabric forms part of the outfit and is tied to the waist by long strings. Thus the work garment found a precise and clear form and a more technical and professional appearance, emphasized by the use of denim, the typical fabric of jeans and many of the work clothes worn by men which in that period was becoming an international symbol of the American identity and culture. The popover dress, of which hundreds of thousands were sold over the space of little more than fifteen years, partly because of its very reasonable price, was also produced in other materials: one of these was gingham, a very popular fabric in America, especially for women's, children's and leisure wear.[8] Twenty-five years after the appearance of the Hoover apron, it was on the occasion of another war, and the consequent recruitment of the female labor force by industry, that the problem arose once again of providing suitable attire for those women who, without the support of domestic servants, found themselves having to tackle the household chores and reorganize them in an efficient and independent way. Hence the

mass production of utility dresses represented an appropriate response to the needs of a period in history in which women had to take over the jobs left vacant by men sent to the front and, at the same time, go on looking after their families.

NOTES

[1] Colette Rosselli, "Solo una donna in America taglia e cuce i suoi abiti," in *Grazia*, April 30, 1953, cited in Ivan Paris, *Oggetti cuciti. L'abbigliamento pronto in Italia dal primo dopoguerra agli anni Settanta*. Milan: Franco Angeli, 2006, p. 92.
[2] Natalie Kneeland, *Aprons and Housedresses*. Chicago-New York: A.W. Shaw Company, 1925.
[3] *Patterns for Blouses and Dresses*, Women's Institute of Domestic Arts and Sciences. Scanton PA, International Educational Publishing Co., 1917, p. 9.
[4] Anne Hollander, *Sex and Suits. The Evolution of Modern Dress*. New York-Tokyo-London: Kodansha International, 1994, p. 136.
[5] Thorstein Veblen, *The Theory of the Leisure Class*. Harmondsworth: Penguin, 1979 [orig. ed. 1899], p. 15.
[6] Kohle Yohannan and Nancy Nolf, *Claire McCardell. Redefining Modernism*. New York: Harry N. Abrams, 1998, p. 67.
[7] Claire McCardell, *What Shall I Wear? The What, Where, When, and How Much of Fashion*. New York: Simon and Schuster, 1956, p. 85.
[8] Caroline Rennolds Milbank, *New York Fashion: The Evolution of American Style*. New York: Harry N. Abrams, 1989.

Silvana Mangano in *Riso amaro*,
directed by Giuseppe De Santis, 1949.
Archivio Storico del Cinema - AFE

Housedresses and Movies

In strong contrast to the aseptic and efficient image associated by the American media with simple models of clothing for the home in the 1940s and 1950s, the cinematographic use of the housedress or *vestaglietta*, a recurrent presence in Italian postwar movies, was often accompanied by an underlining of its connotations of sensuality and of eroticism. Especially in the films that recounted the life of a working-class and suburban Italy, this garment constituted one of the most important elements in the combination of symbols which, as Antonella Giannone and Patrizia Calefato put it, gave rise to an "image of the Italian woman that, actualized chiefly overseas, owes a great deal [...] to the cinematographic costumes of neorealism and the way in which they have contributed to the creation of unforgettable female characters."[1] One of these figures was Silvana, the rice-weeder heroine of Giuseppe De Santis's 1949 movie *Riso amaro* (*Bitter Rice*). In many scenes the actress Silvana Mangano wears a housedress that proves to be no less powerful in its erotic allure than the more famous outfit she dons for weeding rice: this is especially true in the shots in which she is shown slipping the dress on or off, with a pause in her movement that prompts the viewer's gaze to focus on her black shift. With the buttons undone or the hems easily sliding apart, the protagonist's housedress plays a part in the definition of one of the characteristic elements of the film, "the attention to the language of the body [...] to the presence of symbols of history and society in this body."[2] A different interpretation of the stereotype of the young woman of the people, which in this case became a figure representative of a gracefully wild sensual energy with greater ties to nature, can be found in Luigi

Comencini's 1953 movie *Pane, amore e fantasia* (*Bread, Love and Dreams*),
starring Gina Lollobrigida. The light dress worn by her character, "la
Bersagliera," which has all the traits of the housedress apart from the
opening at the front, serves to highlight the vitality of the working-class
girl, something which is also conveyed through tears in the clothing
against which her body strains. This representation harks back to an
erotic imaginary that had first been proposed during the years of
Fascism, as is evident from a comparison with Gino Boccasile's covers
for the magazine *Grandi firme*. What was really being suggested in these
drawings, notwithstanding the petit bourgeois and urban setting, was a
model of a less sophisticated and more unsettling woman. But it was an
imagery that, as Elisabetta Mondello points out, did not conform to the
canons promoted by the regime:

> Not even a transformation of the official model into a model of rather too
> marked a popular stamp was welcome: thus the stereotype of the "Signorina
> Grandi Firme" diffused by Zavattini and Pitigrilli's magazine of the same name
> would in the end be opposed and the periodical closed down.[3]

Antonio Faeti, in his preface to the book in which the covers of the
magazine have been reprinted, argues that the model of dress of the
women drawn by Boccasile, "lacks the highly significant input that could
have been made to it by his dedicated adherence to the essence of a
fashion" and that in the depiction of this form of "domestic,
reproductive, rationed eros [...] the girl is adeptly swathed in the
costumes of the film *Grandi magazzini*."[4] On closer examination,
however, the iconography of *Grandi magazzini* seems to have been
filtered in the domestic eros of Boccasile's figures through a vision of the
popular expressivity of housecoats and housedresses.
In the 1955 film *La bella di Roma*, which along with *Pane, amore e fantasia*
(1953) and *Pane, amore e gelosia* (1954) formed Comencini's so-called
romantic trilogy, Silvana Pampanini wears a housedress that is singularly
reminiscent of Claire McCardell's popover dress: the garment and its
rustic check constituted the metaphorical point of contact between the
body of Nannina, an arch and attractive working-class girl, and the place

called "La bella di Roma," the trattoria that she dreams of running.
In this connection it is important to point out that, alongside their erotic
connotations and undertones, the recurrent presence of these clothes in
Italian cinema should equally be attributed to the desire of directors,
screenwriters and costume designers to give an explicitly working-class
character to the settings of the movies. In *Bellissima*, Luchino Visconti's
1951 film starring Anna Magnani, many of the women in the entourage
of the character of Maddalena Cecconi wear housedresses, and this adds
to the consistency of the reconstruction of the lower-class Roman milieu
in which the story is set. Moreover, according to *Bellissima*'s costume
designer, Piero Tosi, many of the clothes worn in the movie – because
of limitations on the budget as well as Visconti's well-known
determination to have his actors dressed in a highly realistic manner –
had been obtained by stopping people in the street and asking them to
lend their clothing for the film.

A similar preoccupation with realism is certainly not unconnected with
the fact that, in one of the opening scenes of *Ossessione* (*Obsession*), the
film shot by Visconti in 1942, about which the director later declared
that his intention had been to make it an "account of a certain type of
Italian society that had remained untouchable: the lumpenproletariat of
the Po Valley,"[5] the protagonist is wearing a housedress. At the same
time, however, the short sequence in which Clara Calamai is changing
her clothes and slips off the garment by undoing the strings that hold the
crossed-over ends together is undoubtedly charged with erotic tension:
the dress that falls from her shoulders and slides down over her body
seems to have been designed expressly to make a gesture of such simple
sensuality, so different from the complicated and clumsy operation of
taking a dress off by pulling it over the head.

Through her way of wearing the housedress, of putting it on and taking
it off, the actress bestows on the scene set in the bedroom the sense of
intimacy and frowziness necessary to the creation of Giovanna's
character. In the novel by James Cain on which Visconti's film is based,
The Postman Always Rings Twice, Frank has the following to say of Cora,
the wife of the owner of the Twin Oaks Tavern with whom he is shortly
to have an affair with dramatic and fatal consequences:

I didn't look at her. But I could see her dress. It was one of these white nurse uniforms, like they all wear, whether they work in a dentist's office or a bakeshop. It had been clean in the morning, but it was a little bit rumpled now, and mussy. I could smell her. [...] She got up to get the potatoes. Her dress fell open for a second, so I could see her leg.[6]

Despite the total difference in setting and details, the scene from *Ossessione* referred to above captures the overall sense of this description, in which corporeity, eroticism and slovenliness are combined in an intense mixture: and the housedress worn by the actress participates fully in the creation of this effect. If we look at the other two major film adaptations of Cain's novel, made in the United States in 1946 and 1981, it is worth noting that while in the first Lana Turner is given a clean white outfit that is a "hygienic" translation of the author's description in the written text, in the later version, which stars Jack Nicholson and Jessica Lange, the latter wears a slightly crumpled and faded housedress, whose presence accentuates the sensuality and turbidity of the character she plays.

In these examples, to the traditional suspension of the housedress between the internal and external space of the home is added a further oscillation between its daytime and nighttime parts. A garment on the threshold of these two areas of domesticity and dress, between an intimate dimension and one of work, the housedress has been used strategically by the cinema, which exploits this indecision to depict situations of latent or explicit eroticism, favored by the persistence of a memory of the dressing gown in a garment used for daily chores.

In the rich range of meanings that cinema finds in the housedress there is also an allusion to the doubtful morality of the female character who wears it, easily conveyed through its proximity – in the spatial, formal and evocative sense – to the bedroom, the negligee and slovenliness. A clear example of the association between housedress and prostitution – a link already made at the literary level, as is evident from the passages of Pirandello and Pavese already cited – can be found in another of Luchino Visconti's movies, *Rocco e i suoi fratelli* (*Rocco and His Brothers*, 1960): the light housedress that Annie Girardot is wearing undone when

Jessica Lange and Jack Nicholson
in *The Postman Always Rings Twice*,
directed by Bob Rafelson, 1981

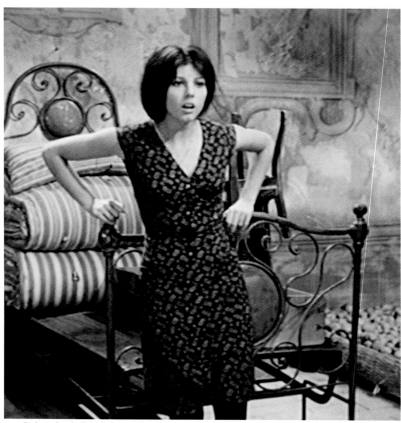

Stefania Sandrelli in *Sedotta e abbandonata*,
directed by Pietro Germi, 1964

she appears on the screen for the first time clearly intimates, without any need for explicit accents of an erotic character, the lack of inhibitions and availability of the young Nadia, and it does not take long to grasp what her profession is.

Poles apart from the hectic Milan of the economic boom that is the setting for *Rocco e i suoi fratelli* is the Sicily which Pietro Germi depicts in *Sedotta e abbandonata* (*Seduced and Abandoned*, 1964): in a climate of changing customs, the director's satire underlines the deep roots of archaic codes of honor in an unchanging land. Here the submissiveness of the taciturn Agnese, who is "dishonored" by her sister's fiancé, is perfectly expressed by the simple housedress worn by a very young Stefania Sandrelli. For her, and for her three sisters, housedresses are in fact exactly that, for their code of use is strictly limited to the family sphere and therefore requires them never to be worn in public.

In the same year as *Sedotta e abbandonata* was made, a more caustic and jaundiced view of the tension between development and backwardness and its relationship with the stereotyped ideas about national characteristics in circulation was presented in Luigi Comencini's episode of the film *Le bambole* (*The Dolls*). His sarcastic illustration of the eventual fate of Ulla, the Swedish woman who has set off for Italy with the intention of finding a true Italian male to father the healthiest of children, is condensed in the image of an almost unrecognizable Elke Sommer in a housedress, holding a child in her arms, heavily pregnant and clad in woolen stockings and clogs.

Here the idea of cultural and social backwardness, conveyed yet again by the housedress, is reinforced by the image of a woman who has no control over her own body and her procreative capacities. The same thing happens in *Teresa la ladra* (*Teresa the Thief*), Carlo di Palma's 1973 movie based on a novel by Dacia Maraini. In one shot of the film the voluminous belly of Teresa, who lives in a state of privation, poverty and marginalization, is barely contained by the worn and too short housedresses she wears one on top of the other, a disheveled layering chosen by the costume designer Adriana Berselli to characterize the working-class and unconventional character played by Monica Vitti. This image is in sharp contrast with that of Salvatore Samperi's popular

film *Malizia* (*Malicious*, 1973), in which the housedress worn by the star, Laura Antonelli, is the garment best suited to the voyeuristic gaze of the male characters and to the erotic negotiations between Angela and the young Nino: it is to the overturning of the rules of this game begun by the young man that the function of delivering Angela from her condition of subjection will be assigned. It is an erotic stereotype of the domestic servant that the pleasure of spying on her body is favored by the postures she assumes while doing the housework and by the way that her dress exposes it to view. This is the case with the famous scene in which Angela climbs a ladder to clean the windows, offering a glimpse of her white cotton underwear, with a detail of domestic frowziness communicated by the snagged border of her stockings.

But in the cinema the housedress has also had the function of supporting the representation of strong female figures, who face up to the difficulties or hardships of life with courage, or who display a stubborn individuality.

In *La ciociara* (*Two Women*, 1957) Sophia Loren puts on a housedress to play the part of Cesira, a woman who has had to deal personally with the consequences of the tragedy of the war. In the novel of which Vittorio De Sica's movie is an adaptation, Alberto Moravia constructed the character through the physical signs of a concrete and vital femininity, attributes that are translated into cinematographic language, in a less explicit manner, through the figure of Sophia Loren and her costumes. Twenty years later, in Ettore Scola's *Una giornata particolare* (*A Special Day*), the actress would wear a housedress again, but in this case a more elaborate model, better suited to the dignity and duties of a member of a family of the urban lower middle class and to describing the daily life of a housewife under Fascism.

In Emanuele Crialese's 2002 film, *Respiro* (*Grazia's Island*), Valeria Golino plays the part of Grazia, a woman who refuses to knuckle under to the behavior that her social group and the family in which she lives consider suitable to her role as wife and mother. Her attire consists solely of a series of housedresses that she wears at home, at work and on her wanderings around Lampedusa, the island on which she lives: the constant use of the housedress is highly representative of the seaside

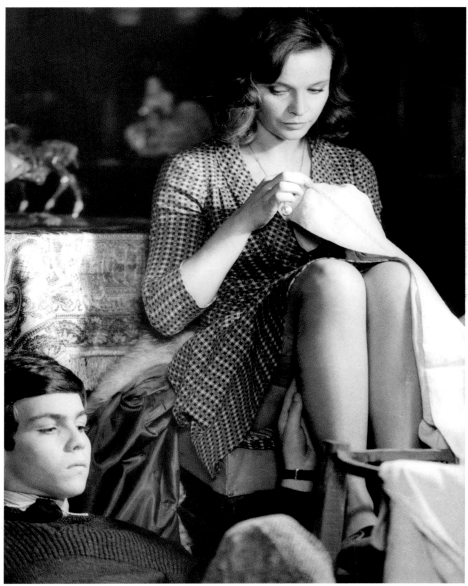

Alessandro Momo and Laura Antonelli in *Malizia*,
directed by Salvatore Samperi, 1973.
Archivio Storico del Cinema - AFE

location and of a context that, in the period in which the movie is set, the end of the sixties, was characterized by a great permeability of the boundaries between the family circle and the social sphere. Finally, it is the slip that once again accompanies the use of the housedress in the images of the film: in many shots in *Respiro*, while Grazia is walking or clambering over the rocks, the hems of her dress part to leave the white of her underwear visible, recalling a former use of lingerie that is also linked with a social code of modesty, a code that Grazia contravenes at the moment she strips off the dress and petticoat to dive into the sea. An exemplary case of the cinematographic use of the housedress is *Volver*, Pedro Almodóvar's 2006 film in which this form of attire serves to construct the character played by Carmen Maura, representative of a social class, a generation and a culture. The story turns around a series of female figures, amongst which stands out that of Irene, whose wardrobe consists almost exclusively of housedresses. Many scenes insist on this fact, as in the sequence in which the camera lingers for a long time on one of Irene's dresses laid out on the bed, as if to evoke her presence, or the one where mother and daughter drape the clothes on hangers to put them in a closet, turning it into a collection of colored patterns: in this as in other shots the housedresses participate in the composition of contrasting decorations that is a feature of the director's visual culture. The popular iconography of the film is inspired by Italian postwar cinema, a model to which Almodóvar pays explicit homage by showing Irene watching a scene from *Bellissima* on television in which Anna Magnani takes off her blouse and is left in her underwear. If in small towns, like the one in La Mancha where *Volver* is set, the housedress may still play the role of a popular and multipurpose garment that can be worn on all kinds of occasions, in the big cities its function is usually limited to that of protective clothing to be worn for housework. Sam Garbarski's movie *Irina Palm* (2007) introduces an ironic and unexpected aspect of this view of the garment, as one reserved exclusively for the privacy of the home. In this interpretation the housedress – of the sort known as a pinafore dress, or referred to familiarly in Britain as a pinny – turns into clothing for a very special kind of work. The protagonist of the film, Maggie, uses it to protect her

own clothes from the possible consequences of her job in a sex club. Since her age makes her unsuitable for other types of activity, she is entrusted with the task of masturbating the penises that are presented to her by unknown clients through a hole in the wall. Alone in her workplace, Maggie tries to make it less demoralizing by furnishing it with personal objects and wearing a flower-patterned housedress. The irony touches on both the attitude of "professionalism" assumed by the heroine, who dons a uniform for her new job, and on the type of uniform chosen, that of a housewife, which creates a further contrast between an idea of everyday familiarity and the transgressive imagery associated with sex for payment.

NOTES
[1] Antonella Giannone and Patrizia Calefato, *Manuale di comunicazione, sociologia e cultura della moda*, vol. V, *Performance.* Rome: Meltemi Editore, 2007, p. 17.
[2] Gian Piero Brunetta, *Guida alla storia del cinema italiano 1905-2003.* Turin: Einaudi, 2003, p. 170.
[3] Elisabetta Mondello, *La nuova italiana. La donna nella stampa e nella cultura del Ventennio.* Rome, Editori Riuniti, 1987, p. 112.
[4] Antonio Faeti, in Gino Boccasile, *La signorina grandi firme.* Milan: Longanesi, 1981, p. VII.
[5] Interview with Visconti in Caterina d'Amico de Carvalho, Vera Marzot and Umberto Tirelli, *Visconti e il suo lavoro.* Milan: Electa, 1995, p. 78. First published in "Vita difficile del film 'Ossessione,'" in *Il Contemporaneo*, supplement to *Rinascita*, April 24, 1965.
[6] James Cain, *The Postman Always Rings Twice.* New York: Knopf 1934.

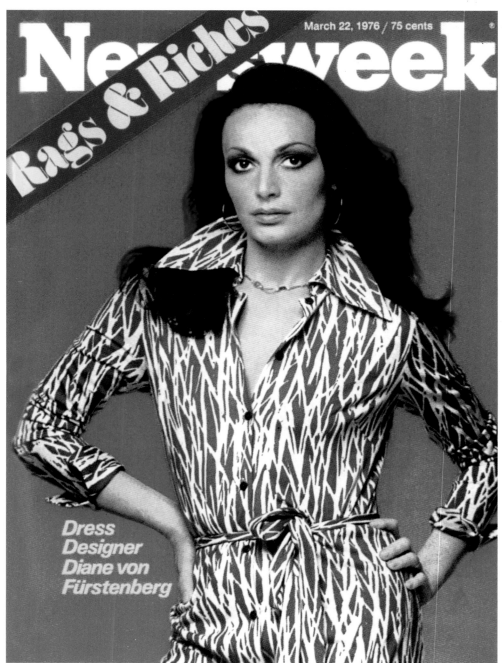

March 22, 1976 / 75 cents

Newsweek

Rags & Riches

Dress Designer Diane von Fürstenberg

Diane von Furstenberg, cover of *Newsweek*,
March 22 1976, photo Francesco Scavullo.
Diane von Furstenberg Archives

The Perfect Dress

"From Homely to Hot": we can borrow the title of an article written by Suzy Menkes in 1993[1] to sum up in an arresting and succinct manner the process that has led to the contemporary version of the housedress, in which the garment worn for housework has been turned into a dress that, with different nuances, emphasizes the sexuality of the female body. The route has not been a straightforward one, as the interpretations provided by contemporary fashion have gone in different directions: from the ennobled updating of the traditional article of clothing to its ironic and parodistic citation and the conceptual reworking of its forms.

To account for this change, which is at once a persistence and a transformation, we can start out from another article in the *New York Times*, published in 1980, which described the evolution of Swirl, the aforementioned manufacturer that had shifted from the production of indoor wear to that of leisure wear able "to take a woman from bedside to a poolside to a candlelit dinner party."[2] The figure of the new housewife is superimposed here on that of the characters of American productions for the cinema and television, in a sensual and striking scenario in which she, attired in a suitable way, is no longer devoted to housework and housekeeping, but to pleasure and relaxation.

Larry Nachman, heir to the family business that had specialized in the production of housedresses since the Second World War, recounts that in the seventies he decided to change strategy and aim at widening the range of uses for indoor wear. While he knew that housewives did not like to change their clothes just to go shopping, he was also aware of the fact that they had become much more sensitive to fashion. Whence the company's decision to create a type of lounge wear (or "pleasure wear")

based on the principle of "in and out": i.e. of clothes to be worn at home but that were also suited to its immediate surroundings and to relaxed social occasions that did not call for much formality.

Since the fifties in fact, the United States had seen a proliferation of "specialized" garments like the brunch dress (or duster) and the patio dress: a diversification – and one that was to some extent only a question of terminology – which went hand in hand with the emergence of the model of the middle-class suburban family home, adapting itself to the spaces of the house and contributing to shaping the dream of a lifestyle. The name of the patio dress in itself evokes the yard of the detached house, an American "domestic symbol, national icon" that "represents a zone of uncertainty, a sort of borderline between private and public space" and, like the new clothing designed for it, came to be "identified as a synonym of domestic harmony and mirror through which to create the public image of private situations."[3]

It is against this background that we should set the success, in the seventies, of the wrap dress, a model that rehabilitated and ennobled the housedress, turning it into an elegantly modern and very feminine outfit. Abandoning both the formality of elegant attire, considered outdated with respect to the exuberance of the new fashions, and the severity of the classical American woman's uniform summed up in the phrase "dress for success," Diane von Furstenberg identified a new way of updating the wardrobe of many women by introducing some elements of fashion into a simple type of dress. This passage entailed the transformation of a working-class model, linked to a carnal image, into an example of a fashionable garment of measured and controlled sensuality.

The wrap model is considered an icon of the seventies, a uniform for a large number of women which enhanced female sex appeal, in a process of sexual liberation and at the same time of social change (interpreted in a radical way just a few years earlier by the unisex style): with the slogan "feel like a woman, wear a dress," her proposal of a mode of dressing centered on the model of an emancipated woman was launched on the American market, offered as an example of comfort and practicality, of accessibility to fashion on the part of a public that rejected the shabby

housecoat and that had begun to go out to work in ever greater numbers.

At the end of the sixties her collaboration with the Italian entrepreneur Angelo Ferretti had allowed Diane von Furstenberg to gain a thorough understanding not only of the techniques used in the printing and manufacture of jersey, but also of the characteristics of the design and the working of the finished product: as she has said herself, Italy was undoubtedly the country that had the greatest influence on her development as a creator of fashion.[4] The results of her work seemed to indicate her adherence to a trend born in the fifties with boutique fashion, a style that had given rise to a "product of pure Italian brand," initially based on a predominantly artisan and small-scale system of manufacturing.[5] Later on, the expansion of this market had also been favored by the great success of items in printed knitwear, silk jersey or synthetic material, which bore the signatures of well-known designers. The simplicity of the forms of these garments was ennobled by highly characterized graphic motifs, which became a strong distinctive mark of their own brand for each designer. For Pucci these were large decorations in which heraldic forms and mannerist colors were blended with shapes and colors of futurist inspiration, while for Roberta di Camerino they were *trompe-l'oeil* prints that reproduced tailoring elements on the flat surface of the jersey or fabric. With the Falconetto brand, the lush floral patterns of Ken Scott had been transferred onto simple knitted garments, helping to renew the popularity of his kaleidoscopic designs. Thus a non-tailored kind of clothing that was easy to keep in good condition had been introduced into fashion, compensating for the reduction in the typical features of formal garments with the exuberance and recognizability of its decoration. It was above all with Pucci's creations that the expressive possibilities of light and elastic jersey were taken to an extreme, as it was used to cover the body completely with a new and gaily colored skin.[6] The fluidity of these new garments was presented, in the publicity of that period, as a suitable response to the requirements of practicality, simplicity and liberation from excessive formality in order to permit a more relaxed way of life. Women's wear adapted to the new world of leisure, plane

flights and the brief vacations of an affluent class was mixed with the exotic inspirations and the libertarian spirit of the colorful and scruffy street style of the seventies.

Following this tendency Diane von Furstenberg had identified and developed the form of the wrap dress, a model that, partly through the use of jersey, emphasized strongly the female figure. In comparison with the shirtwaist, this garment resembling a dressing gown was more reminiscent of the style of the twenties and thirties, a taste that found expression in graphic design as well during the seventies. In addition to describing the art deco prints and floral and spiral decorations of the new models of dress in Diane von Furstenberg's fall collection, an article published in the *New York Times* in 1975[7] stressed the characteristics of easy maintenance and relative cheapness of a garment that, at the same time, had established itself as a status symbol: these were judged to be the essential reasons for the success of the wrap dress, as had already been suggested by the article's title, "Basic Dresses in Sexy Prints and Washable."

The variety of the garments was based chiefly on their different lengths and on the range of printed decorations: the limitation of form was compensated by the differentiation of the accessories, something on which great emphasis had been laid in the strategies used to personalize clothing in those years. While the minute patterns of working-class housedresses had been used in the early models, the motifs had grown larger and more aggressive in the following years, as in the case of the leopard-skin, snakeskin and zebra prints. This was a variation of the traditional range of patterns that, in an article of clothing in which this aspect is so decisive, constituted a significant change. It marked a shift from the assimilation of the woman dressed in flowers to a concept of tamed and gentle nature to an interpretation of the feminine in the form of a wild and threatening nature, following a stereotype that has been proposed in various periods and with different meanings. In the sixties the animal-skin design was characterized by the terse line of pop graphics: in 1966 Rudi Gernreich had presented an outfit in three variants of animal skin – tiger, giraffe and cheetah – in his collection, achieving a total sheathing of the body through the application of the

decoration to shoes, stockings and headgear as well. In the following decade the radicalism of Gernreich's total look was partly abandoned and the pattern of the animal skin took on a more realistic appearance, lending it a more exotic eroticism: a different way of manifesting a liberated female sexuality that to some extent harked back to the popular iconography and glamorous clothing of the American actresses of the fifties.

A garment in animal-skin fabric could be found in many women's wardrobe: Diane von Furstenberg tells the story of how her driver used to count, on their way to the office, the number of passersby wearing a dress with a snakeskin print. In 1976, a year in which she sold around twenty-five thousand wrap dresses a week, the designer's picture appeared on the cover of *Newsweek* with the words "rags and riches" written in one corner.[8] This was the period in which the names and the signatures of designers began to acquire ever greater value in the promotion of fashion. The image of Diane von Furstenberg and her connections in the fashionable and artistic milieu of New York made a significant contribution to boosting the brand's reputation. At the parade of her Fall 1978 collection all the models wore a mask with the features of her face, while on another occasion a wrap dress was displayed on a mannequin made in her likeness at an American department store. The designer's name, lifestyle, beauty and professional success had an important function in a form of total communication in which product and manufacturer tended to be identified. In this way Diane von Furstenberg showed that she had taken over another peculiarity of the initial phase of Italian fashion, adapting it to the needs of a changed social dimension: the ability to place the biography and aristocratic *savoir-faire* of certain couturiers at the disposal of a less exclusive public, extending this offer to a broader stratum of the market.

In the seventies Roy Halston, another prominent figure on the American fashion scene, came up with a different interpretation of the dressing gown, taking his inspiration from the cinematographic imagery of Hollywood, partly through the use of more sophisticated and striking materials. From this point of view the source of his wrap dresses of purple velvet, his dresses of flower-printed silk that fell softly over the

body or his robes of gold lamé can be identified as the glamour of the movie stars in dressing gowns of the years between the wars, rather than the essentiality of the housedress. In this case too images of New York nightlife, of the Studio 54 discotheque where the American designer used to go with a retinue of young Halstonettes, served as a backdrop to the clothes and prepared the ground for one of the scenarios of the exclusive spectacle of the eighties.

It was in this decade, moreover, that the development of the system of fashion design led, amidst a great variety of different ideas, to the proposal of more structurally complex forms, in the name of a new sartorial quality that was welcomed by many women for its ability to compete with the formality of the male professional dress code. These changes, along with the emergence of a new language of contamination between styles and genres and the appearance of tendencies to transgression and excess in the culture and fashion of those years, led to the decline of the housedress. On the other hand, within just a few years, housedresses and wrap dresses had become part of the new languages again, transfigured in the contrast with "combat" elements like Dr. Martens boots, and superimposed on other garments. This revival paved the way, along with the repositioning of historic brands like Pucci, for the reentry of Diane von Furstenberg's name onto the market in the nineties.

In the same period several designers, including the American Anna Sui, had come up with their own version of street style that reinterpreted garments like the housecoat, apron and other elements of popular culture and clothing. The references for Anna Sui's work come chiefly from the musical and artistic milieu in America, and above all the experiences of pop culture. Mixing up reminiscences of British Victorian decoration, forms and elements of American fashion and visual communication from the period between the forties and the sixties and numerous citations of a cinematographic character, the designer has defined a personal way of interpreting the punk and grunge styles. Anna Sui has also cultivated her taste for citation by rummaging through flea markets for items of clothing, especially housecoats and kitchen aprons, of which she possesses a collection. In an interview, Sui has told of

being teased by her friends over the contradiction between this passion for aprons and her total incompetence in the kitchen: for her, who does not remember ever seeing her mother in an apron, the garment is in effect "a passe kind of thing."[9]

In parallel to this approach based on citation and postmodern superimposition and following a course that moved in the opposite direction, a line of conceptual research was pursued in the nineties, focusing on the structural principles of clothing, on their breakdown and on an attempt to strip them of strong connotative elements. Some designers had gone so far as to work on the forms, rediscovering the possibilities of joining elements together with strings and laces and building up several layers and transparences of fabric, at times recalling the elementary language of women's indoor wear, and aprons in particular. When asked about a possible reference to these garments in their own collections, however, both the Franco-Swedish designer Marcel Marongui and the Austrian Helmut Lang declared that their inspiration had nothing to do with the apron worn by housewives. Lang has stated that his model was the long white apron worn over black trousers by waiters and that his objective was to make the apron "a basic piece for the nineties," just as had happened previously with the T-shirt: although originally underwear, this had become a fundamental element of contemporary clothing.[10]

During that period the Austrian designer had shown aprons tied over see-through garments or wrapped around pants and shorts, in step with some contemporary choices made by Anne Demeulemeester, who developed overall-like forms and models tied at the back of the body, in a sort of citation halfway between the surgical gown and the housedress. The principle of layering, as well as the idea of mixing up different patterns, was also a practice typical of Anna Sui's work, and a direction that she has continued to follow in recent years. Her predilection for the use of decorated fabrics and the combination and the superimposition of different patterns has led her to create refined effects of domestic bricolage that recall the layers of housedresses seen in *Volver*: an example is a garment in her 2007 collection made out of a fabric with small motifs that is visible under an apron printed with different colors and patterns.

In the nineties, although in a completely different form from the creations of the aforementioned designers, Ralph Lauren had presented a model inspired by the flower-patterned housedress in his collections and, with different intent, Marc Jacobs had recalled the prints and simplicity of such garments in some of his tunics.

In the 1993 article cited above, which commented on these assorted domestic references in the collections of the period, Suzy Menkes raised some doubts about the anachronism of the housedress and the apron as a source of the inspiration for the designer's proposals, objecting that "washing machines and sweat suits – not to mention fast food and microwave ovens – have made redundant a centuries-old protective garment."[11] This did not mean that the female presence had vanished from kitchens, but that the uniforms worn by women to do the housework had changed, disguised, as can be deduced from Menkes's observation, in the form of sports and casual wear. It is not irrelevant, moreover, that the problem is posed by the journalist in terms related to the obsolete aspect of housedresses and aprons: if it is true that fashion "is a tiger's leap into the past," the form that *par excellence* does not conform to laws of diachronic progress, then it might be thought that Menkes's comments stem from another motivation, that of a certain distrust of the subjects chosen for these resuscitations. A motivation that is made explicit by the journalist later on in her article, when she asks if the reemergence of the apron might not signify a return, metaphorically speaking, of women to the kitchen. In reality, from a relationship between stylistic revivals and historical recurrences it might be deduced, on the contrary, that the citations of aprons and similar garments in the collections of designers are an indication of the remoteness of these articles from everyday life today. The lack of meaning that they appear to have in the culture of young designers is what allows the latter to transform them into the "pure" form of fashion, stripped of their symbolic value.

On the other hand Menkes's perplexity over the fact that, in the early nineties, "even Ralph Lauren, a champion of men's wear for women, turned the floral housedress into fashion" seems to voice that tendency in the culture of the fashion to consider clothing which has a precise and

sculptural structure better suited to the social, less "intimate" dimension of dressing. As Guia Soncini wrote in a recent article devoted to the *vestaglietta*,[12] in which she ironically laments the excessive "pliability" of a garment quick to reveal – or, worse still, draw attention to – aspects of the body regarded as negative, one of the principal reasons for its disrepute is precisely the unsuitability of this clothing to "lending support." The question raised by the journalist seems to go beyond the obvious requirement for an improvement of the physical aspect, and the demand for support appears also to hint at the need for a partnership between clothing and body, indispensable to the complexity of daily relationships and life.

By reinterpreting home wear in an ironic key and hybridizing it with elements of contemporary culture, designers and street style cleared the way for a further and different revitalization of the housedress, considered an object representative of the female subculture of working-class consumption. A similar operation had previously been carried out with regard to the slip and other items of underwear, at first salvaged from flea markets and then made the prototype for the development of new modes of dress, continuing with the process of bringing female lingerie from the inside to the outside that has been a mark of various periods.

In addition, the renewed interest in the designers of the sixties and seventies has brought the fashions of that time back into the limelight: multicolored garments in soft and silky materials and an ample repertoire of decorations, ranging from prints of tropical inspiration to sixties-style geometric patterns, not excluding monochromatic variants and less smooth materials. From Diesel, which has replaced the knotted ties of the housedress with a zip to join the two panels of fabric on one side, to Missoni, which applies its vibrant colored patterns to the jersey of the wrap dress, there are few producers of fashion today who have abstained from offering a wrap dress. Versace has come up with a sartorial interpretation consistent with the brand's luxury image, a version in which the drapery and soft black fabric have proved themselves suited to the tradition of the Cruise collections. Emporio Armani has produced a housedress in a light floral material while Pucci,

in the tropical fabric of his wraparound model, has revived the acid colors of sixties' prints.

In London, inspired by the work of Pucci and Diane von Furstenberg, the designer Issa Helayel has created collections comprising many variations on the theme and the decorations of the wrap dress, focusing publicity about the product on the possible reconciliation of contrasting concepts, like comfort and seduction, work and leisure. Describing the suitability of the "perfect dress" to be worn "from bedroom to boardroom," the presentation text of the Issa brand extended as far as the company headquarters that in-and-out movement which, in the seventies, had circumscribed the spatial pertinence of the housedress to the immediate neighborhood.

The biggest ready-to-wear clothing chains, including Mango, H&M and TopShop, have also adopted the simplicity of the wrap dress with the speed typical of this sector. At the same time, numerous replicas have been made by small manufacturers which find it easy to produce these garments. The pervasiveness and media interest that have accompanied the revisiting of this model are typical of a fad, and the comments in the specialist press registering and assessing the phenomenon have put forward arguments that help us to understand the reactions to the coming back into fashion of an item of clothing which inevitably seems to dust off an outdated and above all non-aristocratic model of femininity, even when worn by influential people. In an article on the wrap dress published by an English tabloid, the photograph of Kate Middleton dressed in one of them is accompanied by a caption in which Prince William's girlfriend is described as looking "mumsy," i.e. maternal and old-fashioned. In her article, entitled significantly "RIP the wrap,"[13] Liz Jones declares her own aversion to a garb that has become very popular among female celebrities and goes on to say that it is suited to pregnant women or middle-aged, curvy ones, indirectly confirming the persistence of a carnal and reproductive female image in a body dressed in this way.

It is interesting to see this article in the light of the one already cited by Guia Soncini, in which the journalist stresses the distance between the image evoked by the English term wrap dress, which suggests a gift

ready to be unwrapped, and the memory stirred by the Italian word *vestaglietta*, which makes one think instead of the dressing gown and a slovenly mode of dress: thus the positive representation of the former is undermined by that of its Italian equivalent, a term which the writer considers better suited to revealing the authentic essence of the garment. One of the points on which the promotion of modern housedresses has focused is their ability to meet the need of clothing, with a single solution, the different roles that many women have to play today, while maintaining a strong and unambiguous sexual identity: neither this presumed need, nor still less the response that is made to it, however, seems to convince the various commentators cited so far. In a different sphere, that of an artistic project, the theme of the specialization of the garment in relation to place, time and social role has been tackled by Andrea Zittel. In her works, both the design of clothing and the construction of spaces to live in epitomize some of the questions raised up to now on the relationship between identity, work, living space and social structure.

In one of her recent interventions, *Smockshop*, the reference to the housedress is not exclusively formal in character, but also entails a reflection on the relationship of modernism with efficiency, taste and the orientation of choices that even embrace concepts of hygiene, morality and social mobility. All these themes regard individual and collective styles of life in general, and seem particularly significant with respect to the attempt, made up to this point, to grasp the subtle and mutable relationship between the form of domestic women's clothing and the space of the house.

Drawing on the principles developed by those exponents of Russian constructivism who had chosen to adopt geometric modules in their design of clothing, partly as a means of maintaining the integrity and formal origin of the fabric, Zittel has determined the basic form of her smock. Deciding in addition to make this model out of a single rectangle of material, the artist, not without a touch of irony, has further radicalized the arbitrary nature of this choice, even though it is not one devoid of sense. Basing the design on this elementary form, made up of two pieces of cloth that are fastened at the back and the front of the

body respectively (recalling the structural and practical principle of some versions of the housedress), Andrea Zittel launched her initiative *Smockshop* in 2007. The project involved over two hundred artists in a joint work: each of them, by interpreting the basic form of the garment personally, has participated in an attempt to experiment with the concept of variety within uniformity.

The idea of *Smockshop* stems from a utilitarian and reductive principle already tried out in the 1991 project *A-Z Six Month Seasonal Uniforms.* Prompted by the need to dress in a way suitable for her job (she was working in an art gallery at the time), Zittel had embarked on an artistic intervention that entailed the design and making of a new dress every six months, a uniform to be worn every day until the time of the next seasonal change. The artistic project, which referred to a concept of total design, was then extended to the invention of the Comfort Unit, a minimal dwelling that meets all the needs of contemporary life by reconciling, in a paradoxical and exaggerated way, the requirement of comfort and privacy with that of rationality and efficiency.

These works, along with the majority of the artist's interventions, are rooted, as she herself has declared, in a series of reflections on the character of her cultural formation and the environment in which she grew up, both permeated by the idea of progress and rationality and by the optimistic ambitions of the Modern Movement.

On the one hand these reflections on the motifs, the culture and the products of modernism can be traced back, sometimes even in their formal references, to the experiments with the design of the housedress that were made as part of the wider-ranging project of rational organization of domestic space. On the other the aspiration – present in the history of the proposals of garments like the wrap dress – to reconcile such dualities of life as privacy and sociality, freedom and constraint, elegance and comfort, is an aspect that can be directly related to Zittel's research: the artist, as Tina Yapelli has written, focuses on the "binary relationship of concepts such as self and other, work and leisure, art and commerce," and, "taking into account popular perceptions of comfort, quality and aesthetics," express "the passionate American desire to structure one's existence in order to reconcile life's intrinsic duplexities."[14]

NOTES

[1] Suzy Menkes, "From Homely to Hot," in *The New York Times*, January 17, 1993.
[2] Anne-Marie Schiro, "A dress business grows, but stays in the family," in *The New York Times*, August 16, 1980, p. 46.
[3] Maria Luisa Frisa, Mario Lupano and Stefano Tonchi (eds.), *Total Living*. Florence-Milan, Pitti Image-Charta, 2002, p. 15.
[4] http://www.fashionmagazine.it/news/pages/show.prl?id=14155 (in Italian).
[5] Ivan Paris, *Oggetti cuciti. L'abbigliamento pronto in Italia dal primo dopoguerra agli anni Settanta*. Milan: Franco Angeli, 2006, p. 26, n. 2.
[6] Paola Colaiacomo and Maria Luisa Frisa, "Some Random Notes on Italian Fashion. The Fashion of Postmdernism" in Kaye Durland Spilker, Sharon Sakado Takeda, *Breaking the Mode: Contemporary Fashion from the Permanent Collection, Los Angeles County Museum of Art*, Milan: Skira International corporation, 2008, pp. 23-33.
[7] Bernardine Morris, "Basic Dresses in Sexy Prints And Washable," in *The New York Times*, April 18, 1975.
[8] André Leon Talley, *Diane Von Furstenberg: The Wrap*. Paris: Assouline, 2004.
[9] Suzy Menkes, "From Homely to Hot," cit.
[10] Ibid.
[11] Ibid.
[12] Guia Soncini, "L'arte della vestaglietta," in *Io Donna*, supplement to *Il Corriere della Sera*, March 1, 2008, pp. 179-82.
[13] Liz Jones, "RIP the wrap", in *The Daily Mail*, December 13, 2007.
[14] Tina Yapelli [Introduction], in *A-Z for You, A-Z for Me*, catalogue of the exhibition at the University Art Gallery, San Diego. San Diego: San Diego State University, 1998.

Iconographic Atlas

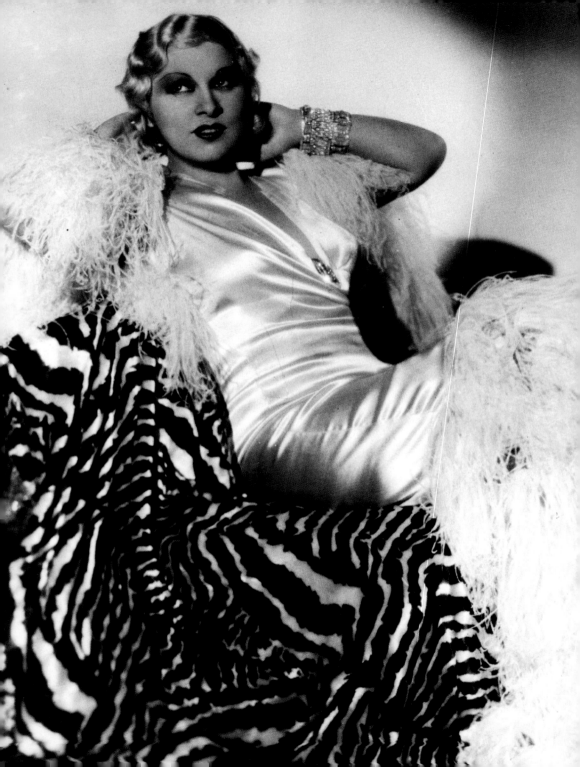

Mae West in dressing gown, *circa* 1933.
Getty Images Archive

17) Madge Evans in a gown, set photo from the film
Grand Canary, directed by Irving Cummings, 1934.
Getty Images Archive

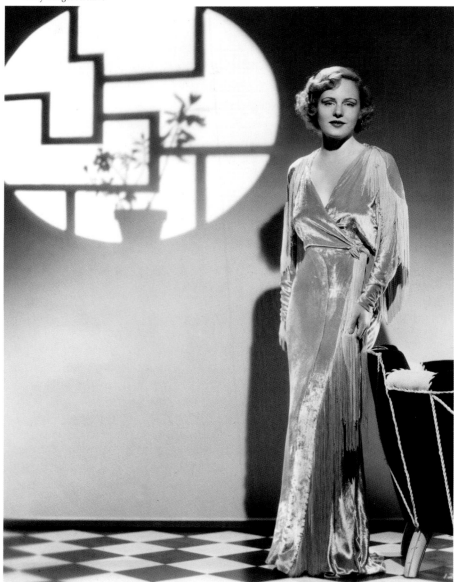

The British actress Margaret Vyner getting ready
to do the housework. From "Spring Clean By Numbers,"
in *Picture Post*, May 24, 1941. Getty Images Archive

The British actress Margaret Vyner doing the housework
on a stepladder. From "Spring Clean By Numbers,"
in *Picture Post*, May 24, 1941. Getty Images Archive

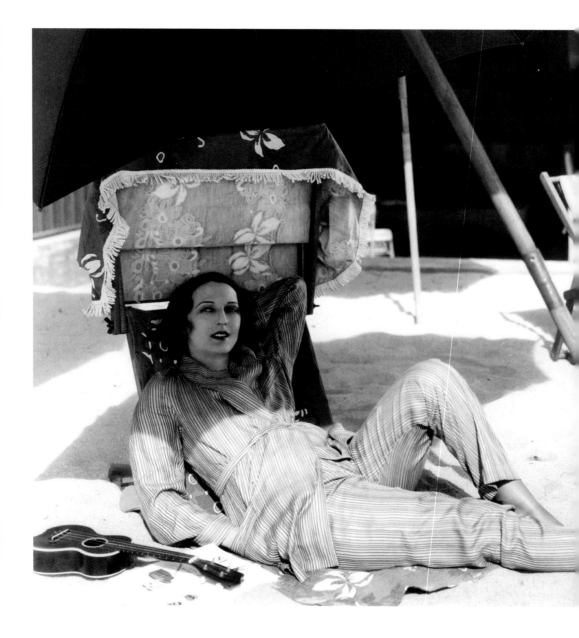

Beachwear, Francavilla a Mare (Chieti), 1936.
Private archive.

Carmel Myers wearing pajamas on the beach,
circa 1930. Getty Images Archive

Model of utility dress. From "Austerity Clothes
for the Fourth Year of the War," in *Picture Post*
no. 1233, 1942. Getty Images Archive

following pages
Mina Van Winkle, head of training activities
at the American Food Administration, 1918.
Getty Images Archive

Hoover apron, American Food Administration, 1918.
Getty Images Archive

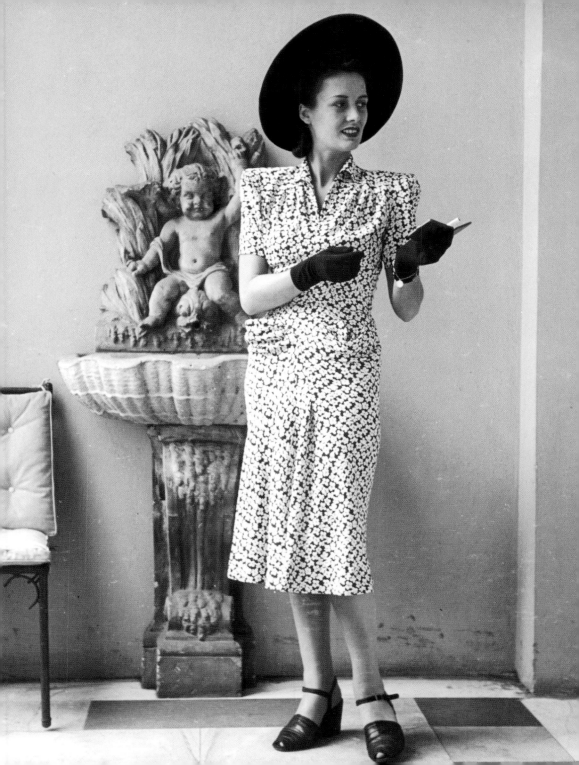

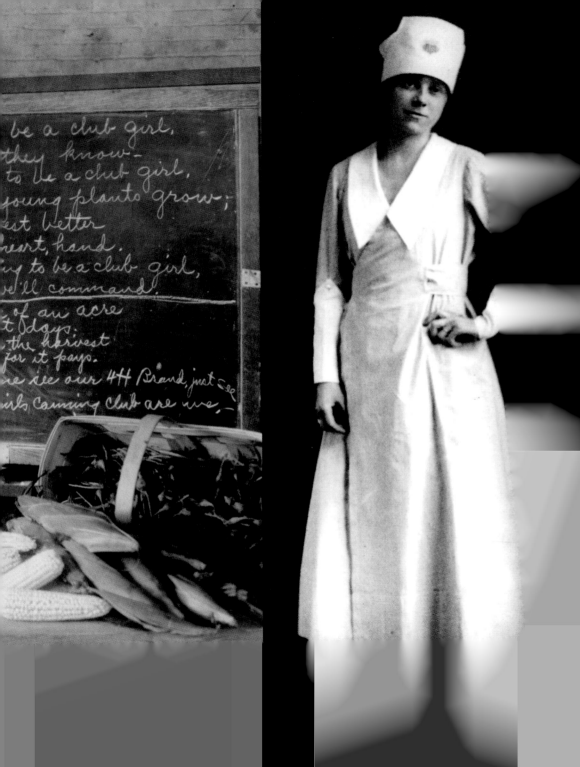

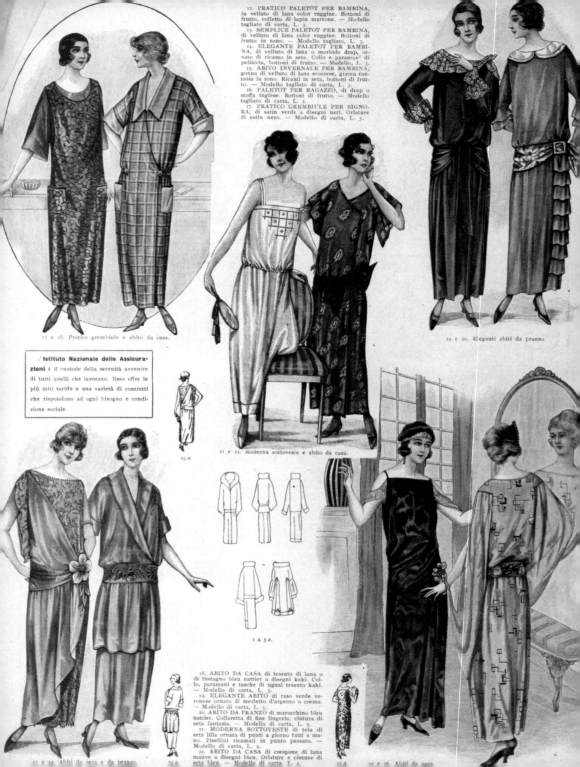

12. **FRATICO PALETOT PER BAMBINA**, in velluto di lana color ruggine. Bottoni di frutto, colletto di lapin marrone. — Modello tagliato di carta, L. 3.

13. **SEMPLICE PALETOT PER BAMBINA**, di velluto di lana color ruggine. Bottoni di frutto in tono. — Modello tagliato, L. 3.

14. **ELEGANTE PALETOT PER BAMBI-NA**, di velluto di lana o morbido drap, ornato di ricamo in seta. Collo e paramani di pelliccia, bottoni di frutto. — Modello, L. 3.

15. **ABITO INVERNALE PER BAMBINA**, gonna di velluto di lana scozzese, giacca fantasia in tono. Ricami in seta, bottoni di frutto. — Modello tagliato di carta, L. 3.

16. **PALETOT PER RAGAZZO**, di drap o stoffa inglese. Bottoni di frutto. — Modello tagliato di carta, L. 4.

17. **PRATICO GREMBIULE PER SIGNO-RA**, di satin verde a disegni neri. Orlature di satin nero. — Modello di carta, L. 5.

17 e 18. Pratico grembiule e abito da casa.

19 e 20. Eleganti abiti da pranzo.

21 e 22. Moderna sottoveste e abito da casa.

23 a.

1 a 3 a.

23 e 24. Abiti da sera e da pranzo.

18. **ABITO DA CASA** di tessuto di lana o di fustagno bleu nattier a disegni kaki. Collo, paramani e tasche di ugual tessuto kaki. — Modello di carta, L. 5.

19. **ELEGANTE ABITO** di raso verde veronese ornato di merletto d'argento o crema. — Modello di carta, L. 6.

20. **ABITO DA PRANZO** di marocchino bleu nattier. Collaretta di fine lingeria; cintura di seta fantasia. — Modello di carta, L. 5.

21. **MODERNA SOTTOVESTE** di tela di seta lilla ornata di punti a giorno fatti a mano. Pisellini ricamati in punto passato. — Modello di carta, L. 4.

22. **ABITO DA CASA** di crespone di lana mauve a disegni bleu. Orlature e cinture di seta bleu. — Modello di carta, L. 5.

25 e 26. Abiti da sera.

Abiti da casa

Eccole, signora, parecchi graziosi abiti da casa. Se la sua veste da camera della scorsa stagione è sbiadita e un po' sciupata, scelga fra queste che le presentiamo. Belle ne sono le stoffe: accanto alla pratica nubiana, lanette e flanelle stampate a disegni nuovi; i fogliami (fig. III) sono veramente chic, siano essi su kaki, come il modello, o su fior di malva, su azzurro o su fragola. Le « pastilles » della veste fig. I sono in rosa antico, giallo limone, azzurro o viola su fondo a mille righe nere e bianche. Il leggiadro leggero disegno dell'abito fig. VII viene solamente stampato su fondo azzurro o nero.

Come si vede, ve n'è per tutti i gusti e per tutte le età.

Nell'andazzo quotidiano della vita attiva una madre di famiglia non ha proprio il tempo di cercar raffinatezze per il suo vestito durante le ore mattutine in cui deve preparare le partenze del marito per l'ufficio e dei figlioli per la scuola, dare gli ordini necessari, curarne l'esecuzione ed assumersi spesso, per aver dovuto diminuire (e quanto!) il numero delle persone di servizio, una larga parte di tale esecuzione.

No, non sono fatte per essa le seducenti, ricche cuffie di merletto e le vestaglie suggestive. Appena uscita dal letto infila la veste da camera, si pettina in modo alquanto sommario e sa porre sui capelli, per mantenerli in ordine, e preservarli dalla polvere, intanto che s'accudisce alle faccende domestiche, una cuffia di tela la cui semplicità è garanzia di nettezza.

Appena andatisene marito e figliuoli, ella indossa sull'abito da casa un ampio e avvolgente grembiule (un camiciotto d'infermiera sarebbe meglio indicato) per dare assetto alla propria camera e a quella dei figli.

Fors'anche ella si dispone ad uscir di casa per far la spesa affine o di supplire all'inesperienza d'una serva giovane ancora o per misura d'economia, giacchè, in tal materia, altra cosa è ordinar le compere e altro il farle a sè. Di fronte alla irregolarità degli arrivi delle vettovaglie alla oscillazione sconcertante dei prezzi, una massaia può a proprio piacimento, variar le compere sul posto, ossia sul mercato o nelle botteghe, mentre una domestica non può o non sa farlo con giudizio e cautela.

Fig. I. — Accappatoio di lanetta a mille righe nere e bianche, sparsa di « pastilles » di colore (viola, giallo, roseo o azzurro) eguale a quello del collare, della cintura e della parte inferiore delle maniche.

Fig. II. — Vestaglia di flanella violacea, guarnita di nubiana color mammola e di fregi riprodotti con lo stampino in quest'ultima tinta.

Fig. III e IV. — Due vesti da casa: la prima di lanetta stampata in color kaki, nero e bianco, guarnita di nastri neri e di disegni riprodotti con lo stampino nei colori ruggine e verde.

Per non indugiar troppo nelle botteghe, essa vi si reca di buon'ora, ossia fra le nove e le dieci; perciò s'affretta a compiere prima la parte che s'è assunta delle faccende domestiche; dopo di che ha appena il tempo di procedere al proprio abbigliamento. D'altra parte le basta, per essere correttamente vestita in quell'ora mattinale, infilare un soprabito sulla semplice e graziosa veste che le serve di abito da casa e che è fatta di flanella, la quale trovasi di tutti i colori.

Quando l'abito devesi portare in casa e fuori bisogna naturalmente attenersi alle tinte « di città » o anche scegliere fra i grigi chiari o medi, l'azzurro vivo o turchino, il viola o il nero, o fra tutte le gradazioni del bruno.

Occorre anche badare alla forma che

la prima di lanetta stampata in color kaki, nero e bianco, guarnita di nastri neri e di disegni riprodotti con lo stampino nei colori ruggine e verde.

deve essere adeguata: niente, dunque, abito aperto davanti fino al basso come quelli delle figg. I e II; bensì preferire forme analoghe a quelle rappresentate dalle figg. V e VI; abiti quest'ultimi che son presto indossati e presto levati e che non s'insaccano punto sotto un soprabito.

Nella sua veste di nubiana (sempre pulita perchè la nubiana è stoffa lavabile), la padrona di casa fa la seconda colazione in famiglia, e poi si abbiglia ove non abbia avuto l'agio di farlo prima o perchè, di ritorno dal mercato o dalle botteghe, ha dovuto o aiutar la fantesca in cucina o sbrigare qualche faccenda urgente. Tante occupazioni, infatti, attendono al varco, in ogni istante, le brave e attive padrone di casa, la situazione economica delle quali sia modesta!...

Ad esse, più che ad ogni altra, s'impone il stretto dovere di stabilire un buono e assennato uso del tempo e di attenervisi nella misura compatibile coi casi imprevisti della vita; in mancanza di che non sarà dato ad esse di trovare un minuto di riposo, quell'ora di tregua e di quiete di cui ciascuna di noi ha bisogno come dell'aria che respiriamo per conservar sano il corpo e ritemprar l'anima.

Fig. V. — Abito da casa, di nubiana grigia, adorno di fregi riprodotti con lo stampino e ricamati poi con seta di gabardine azzurra.

Fig. VI. — Abito da casa di tessuto di lana color rosa gambero con orlature grige della medesima stoffa e con bottoni di madreperla.

Fig. VII. — Abito da casa di mussola di lana azzurra o nera stampata in bianco, con stretta orlatura di mussola di lana bianca e con bottoni di madreperla.

La mia corrispondente aggiunge che, ove si pensasse di far comprendere alle modiste stesse l'illogicità di tanta fretta si farebbe opera vana.

La tregua a cui ho accennato incominciando non si riferisce punto ai teatri.

Il teatro ha esigenze che non ammettono nella moda indugi, riposi di sorta; e il buon esito delle commedie è dovuto anche alla bellezza, alla grazia dei vestiti composti da chi messa in scena oggi, il sarto può benissimo rivendicare la propria parte di collaborazione.

Ma, ripeto, tranne che per il teatro, la Moda riposa attualmente, riposo benefico però il suo, giacchè nella quiete essa con la fervida e sempre desta immaginazione sta già inventando le mille cose graziose che ammireremo fra breve.

Ma se essa riposa, le sue fedeli seguaci

1 a. 2 a. 13 a 14. 3 a. 4 a.

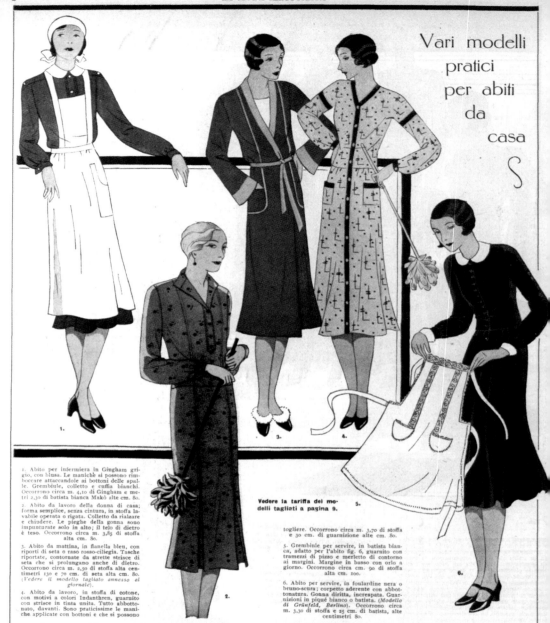

Vari modelli pratici per abiti da casa

1.

2.

3.

4.

5.

6.

Vedere la tariffa dei modelli tagliati a pagina 9.

1. Abito per infermiera in Gingham grigio, con blusa. Le maniche si possono rimboccare attaccandole ai bottoni delle spalle. Grembiule, colletto e cuffia bianchi. Occorrono circa m. 4,10 di Gingham e metri 2,30 di batista bianca Makò alte cm. 80.

2. Abito da lavoro della donna di casa; forma semplice, senza cintura, in stoffa lavabile operata o rigata. Colletto da rialzare e chiudere. Le pieghe della gonna sono impunturate solo in alto; il telo di dietro è teso. Occorrono circa m. 3,85 di stoffa alta cm. 80.

3. Abito da mattina, in flanella bleu, con riporti di seta o raso rosso-ciliegia. Tasche riportate, contornate da strette strisce di seta si prolungano anche di dietro. Occorrono circa m. 2,50 di stoffa alta centimetri 130 e 70 cm. di seta alta cm. 80. (Vedere il modello tagliato annesso al giornale).

4. Abito da lavoro, in stoffa di cotone, con motivi a colori Indanthren, guarnito con strisce in tinta unita. Tutto abbottonato, davanti. Sono praticissime le maniche applicate con bottoni e che si possono

togliere. Occorrono circa m. 3,70 di stoffa e 30 cm. di guarnizione alte cm. 80.

5. Grembiule per servire, in batista bianca, adatto per l'abito fig. 6, guarnito con tramezzi di pizzo e merletto di contorno ai margini. Margine in basso con orlo a giorno. Occorrono circa cm. 90 di stoffa alta cm. 100.

6. Abito per servire, in foulardine nera o bruno-scura; corpetto aderente con abbottonatura. Gonna diritta, increspata. Guarnizioni in piqué bianco o batista. (Modello di Grünfeld, Berlino). Occorrono circa m. 3,30 di stoffa e 25 cm. di batista, alte centimetri 80.

In cucina

Dolce di limoni alla romana. — Prendete tre grossi limoni e fateli cuocere nell'acqua finché diventino molli e immergeteli poi nell'acqua fredda dove vi resteranno almeno 24 ore cambiando l'acqua parecchie volte. Battete poi cinque tuorli d'uovo con 250 gr. di zucchero e aggiungete 150 gr. di mandorle tritate e infine i limoni, passate allo staccio: a tutto questo mischiate i cinque albumi battuti alla neve. Ponete tutto in uno stampo alto almeno dieci centimetri e inviate al forno.

(Dalle ricette Belles Perdrix).

1 a. 1 b. 2 a. 3 a. 4 a. 6 a.

Moda e buon gusto

Vi è stato un periodo, in verità molto breve, in cui venne-ro di moda le unghie rosse come sangue. Fortunatamente questa orribile mania ebbe poca durata ed il buon gusto prevalse sull'eccentricità. Le nostre Signore hanno compreso che la unghie, per rendere belle ed aristocratiche le mani, debbono avere solo quella lucentezza naturale, quel rosso così attraente che solo « La Pietra d'Oriente » sa dare. Questo prodotto (premiato con med. d'oro all'Esp. Intern. di Parigi nel 1928) viene preparato con materie prime importate dalla Cina e non ha rivali nel rendere le unghie robuste e lucide come diamanti! Economico, di lunga durata, si vende in tutte le profumerie al prezzo di L. 5.—

abiti da mattina
e biancheria

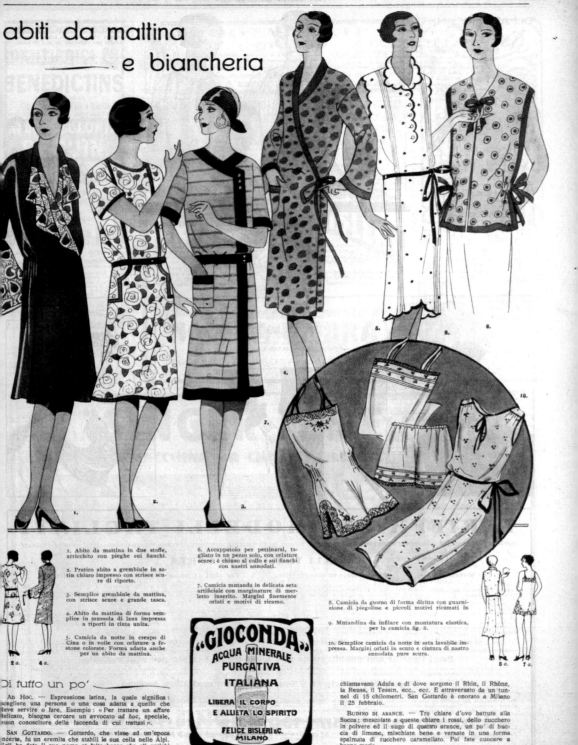

1. Abito da mattina in due stoffe, arricchito con pieghe sui fianchi.

2. Pratico abito a grembiule in satin chiaro impresso con strisce scure di riporto.

3. Semplice grembiule da mattina, con strisce scure e grande tasca.

4. Abito da mattina di forma semplice in mussola di lana impressa a riporti in tinta unita.

5. Camicia da notte in crespo di Cina o in voile con orlature a festone colorate. Forma adatta anche per un abito da mattina.

6. Accappatoio per pettinarsi, tagliato in un pezzo solo, con orlature scure; è chiuso al collo e sui fianchi con nastri annodati.

7. Camicia mutanda in delicata seta artificiale con marginature di merletto inserito. Margini finemente orlati e motivi di ricamo.

8. Camicia da giorno di forma diritta con guarnizione di piegoline e piccoli motivi ricamati in

9. Mutandina da infilare con montatura elastica, per la camicia fig. 8.

10. Semplice camicia da notte in seta lavabile impressa. Margini orlati in scuro e cintura di nastro annodata pure scura.

Di tutto un po'

AD HOC. — Espressione latina, la quale significa: scegliere una persona o una cosa adatta a quello che deve servire o fare. Esempio: « Per trattare un affare delicato, bisogna cercare un avvocato ad hoc, speciale, buon conoscitore della faccenda di cui trattasi ».

SAN GOTTARDO. — Gottardo, che visse ad un'epoca incerta, fu un eremita che stabilì la sua cella nelle Alpi. Egli ha dato il suo nome al folto bosco che gli antichi chiamavano Adula e di dove sorgono il Rhin, il Rhône, la Reuss, il Tessin, ecc., ecc. E attraversato da un tunnel di 15 chilometri. San Gottardo è onorato a Milano il 25 febbraio.

BUDINO DI ARANCE. — Tre chiare d'ovo battute alla fiocca; mescolate a queste chiare i rossi, dello zucchero in polvere ed il sugo di quattro arance, un po' di buccia di limone, mischiate bene e versate in una forma spalmata di zucchero caramellato. Poi fate cuocere a bagno-maria.

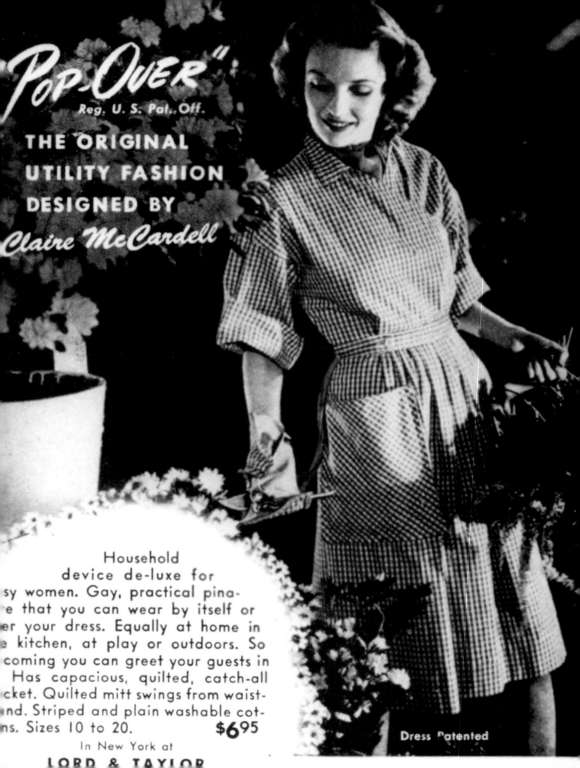

Advertisement for the popover
dress, 1942. From Kohle
Yohannan and Nancy Nolf,
*Claire McCardell. Redefining
Modernism.* New York: Harry
N. Abrams, 1998

Drawing of the popover dress
by Claire McCardell, 1942.
From Kohle Yohannan and
Nancy Nolf, *Claire McCardell.
Redefining Modernism.* New
York: Harry N. Abrams, 1998

previous pages
House, Lunch and Evening
Dresses, in *La Moda Illustrata*,
February 1923

"Abiti da casa"
("Housedresses"), in *La Moda
Illustrata*, February 1923

"Vari modelli pratici per abiti
da casa" ("Various Practical
Models of House Wear"), in
La Moda Illustrata, April 1930

"Abiti da mattina e biancheria"
("Morning Dresses and
Lingerie"), in *La Moda
Illustrata*, July 1930

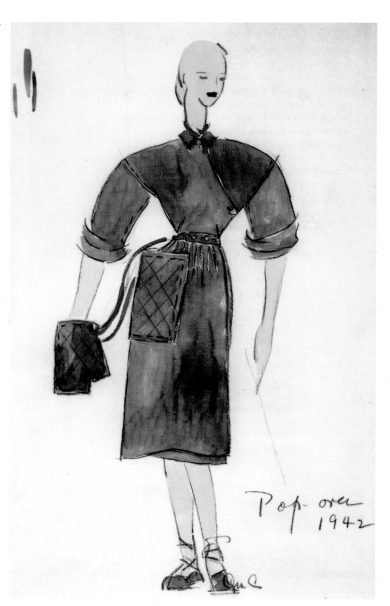

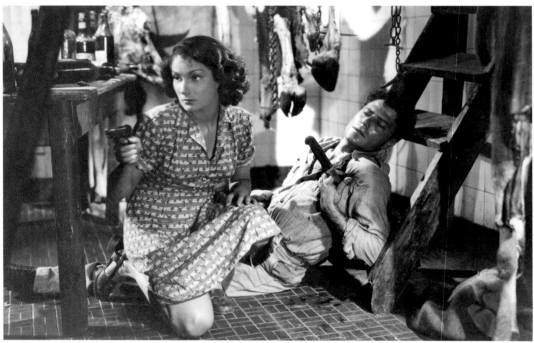

Doris Dowling and Raf Vallone in *Riso amaro*,
directed by Giuseppe De Santis, 1949.
Archivio Storico del Cinema - AFE

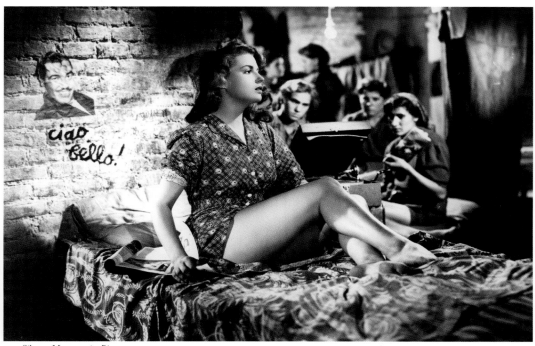

Silvana Mangano in *Riso amaro*,
directed by Giuseppe De Santis, 1949.
Archivio Storico del Cinema - AFE

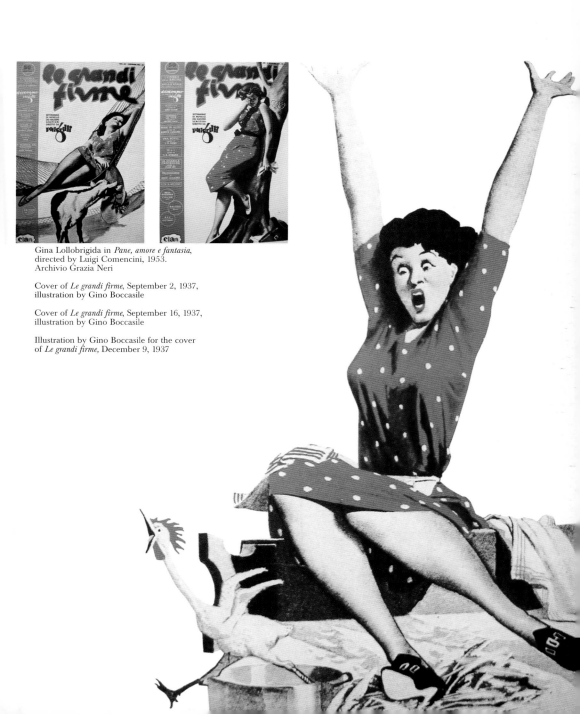

Gina Lollobrigida in *Pane, amore e fantasia*,
directed by Luigi Comencini, 1953.
Archivio Grazia Neri

Cover of *Le grandi firme*, September 2, 1937,
illustration by Gino Boccasile

Cover of *Le grandi firme*, September 16, 1937,
illustration by Gino Boccasile

Illustration by Gino Boccasile for the cover
of *Le grandi firme,* December 9, 1937

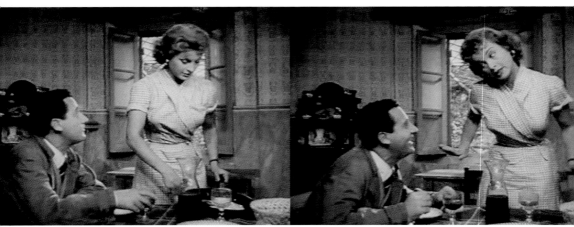

Silvana Pampanini and Alberto Sordi in *La bella di Roma*,
directed by Luigi Comencini, 1955

following pages
Clara Calamai slipping off her *vestaglietta*
in *Ossessione*, directed by Luchino Visconti, 1943

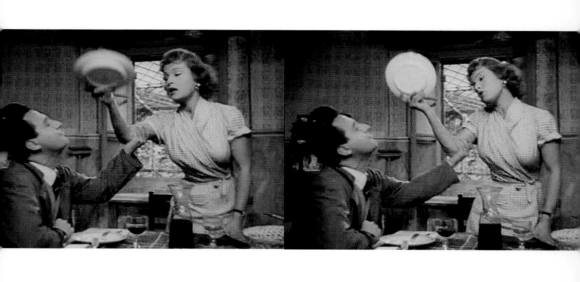

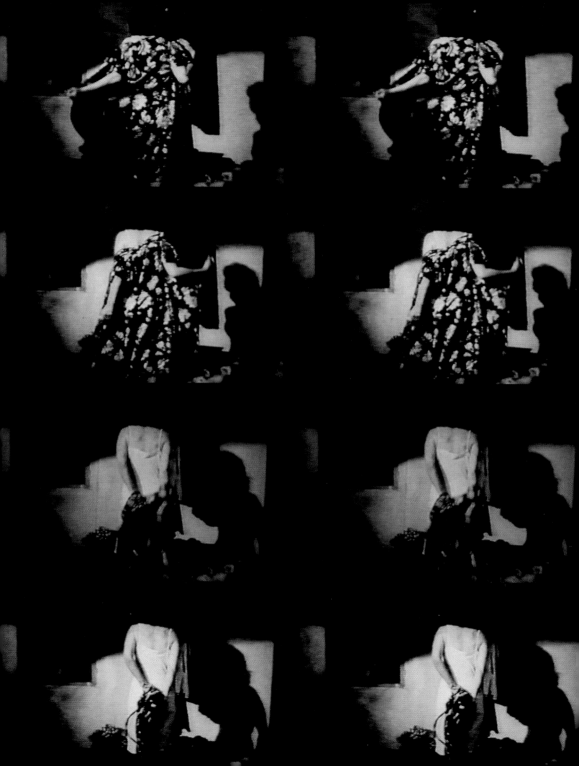

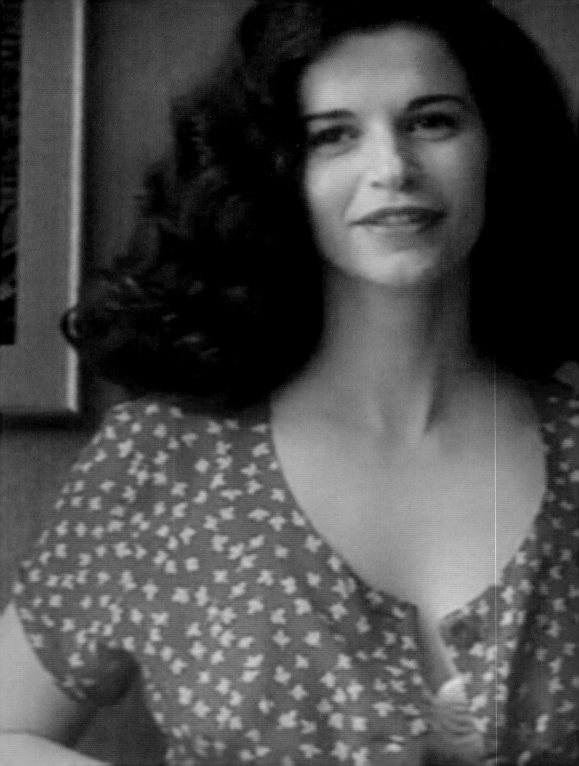

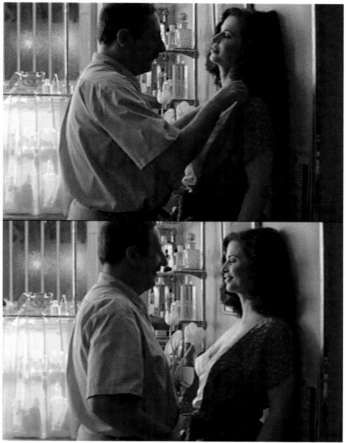

Anna Galiena and Jean Rochefort
in *Il marito della parrucchiera*,
directed by Patrice Leconte, 1990

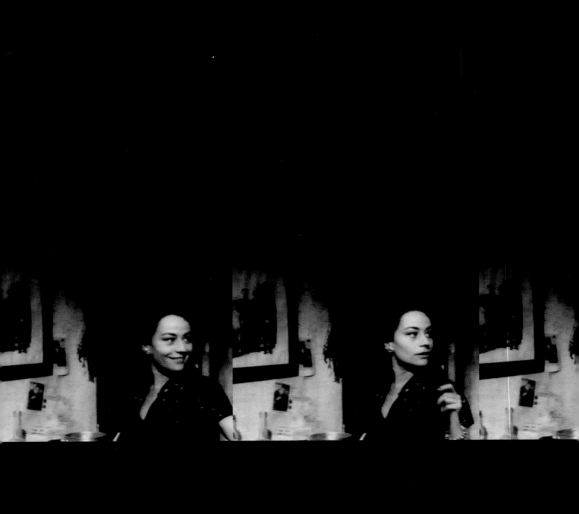

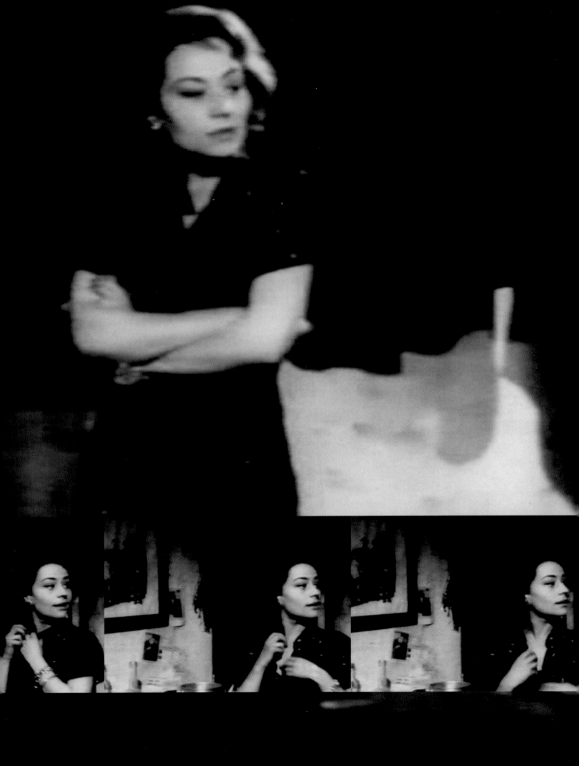

Adriana Berselli, Drawing of a costume for the character of
Teresa in *Teresa la ladra*, directed by Carlo De Palma, 1973.
From Teresa Biondi, *La fabbrica delle immagini. Cultura e psicologia
nell'arte filmica*. Rome: Edizioni scientifiche Ma.Gi, 2007

Monica Vitti in *Teresa la ladra*, directed by Carlo De Palma, 1973

previous pages
Annie Girardot in *Rocco e i suoi fratelli*,
directed by Luchino Visconti, 1960

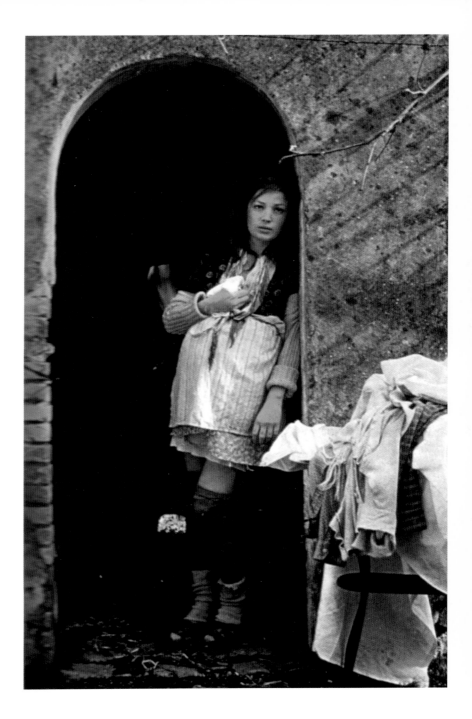

Laura Antonelli in *Malizia*,
directed by Salvatore Samperi, 1973.
Archivio Storico del Cinema - AFE

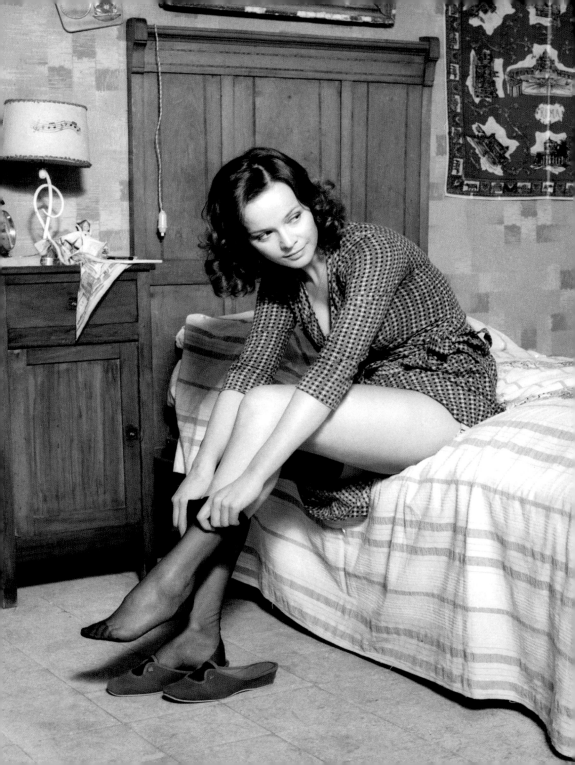

Sophia Loren and Raf Vallone in *La ciociara*,
directed by Vittorio De Sica, 1960.
Archivio Photomovie Collezione

following pages
Sophia Loren in *Una giornata particolare*,
directed by Ettore Scola, 1977.
Photo Tazio Secchiaroli © David
Secchiaroli/Photomovie

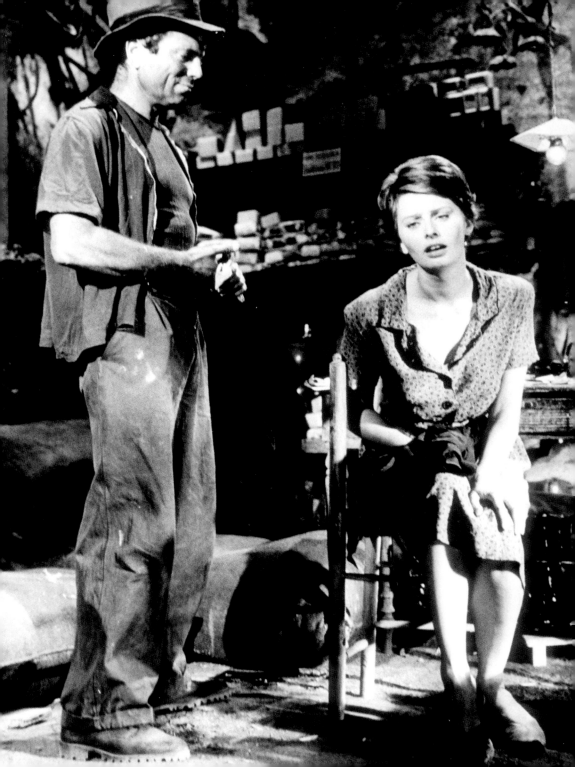

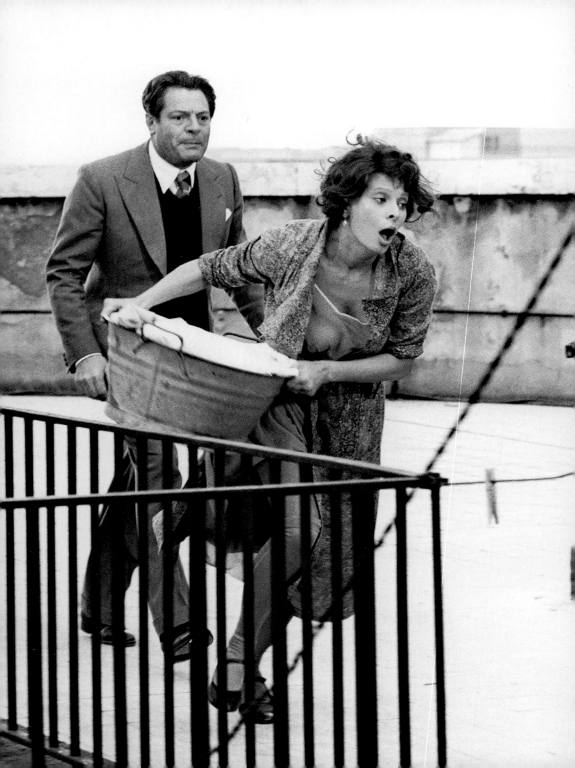

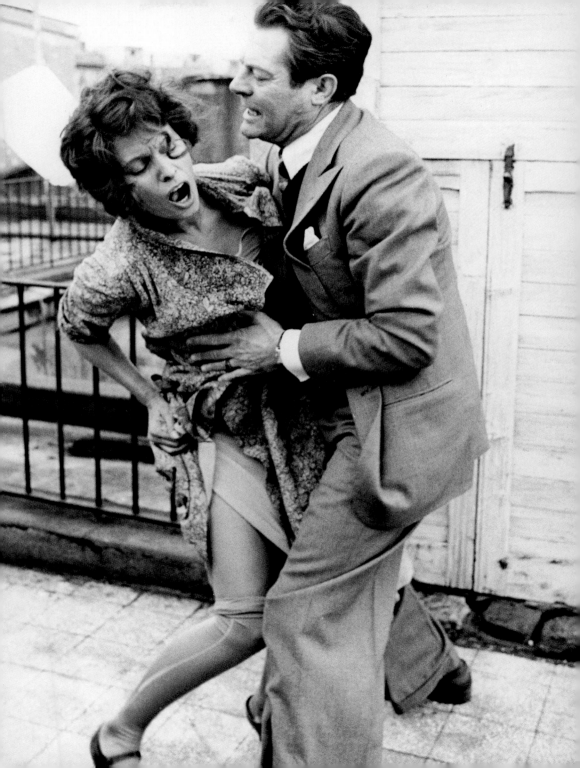

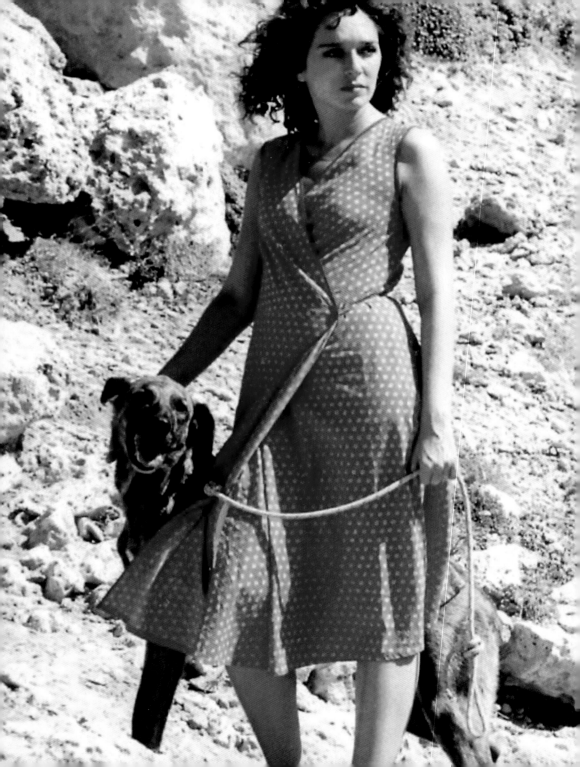

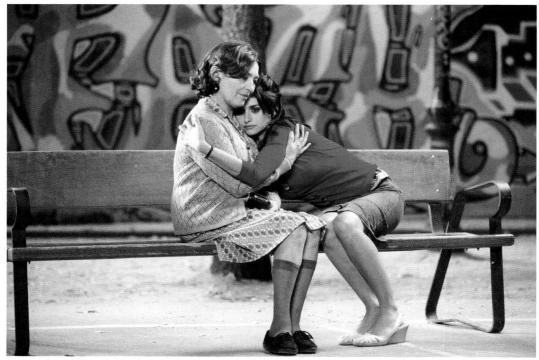

Carmen Maura and Penelope Cruz in *Volver*,
directed by Pedro Almodóvar, 2006

Blanca Portello in *Volver*,
directed by Pedro Almodóvar, 2006

previous pages
Valeria Golino in *Respiro*,
directed by Emanuele Crialese, 2002.
Archivio Grazia Neri

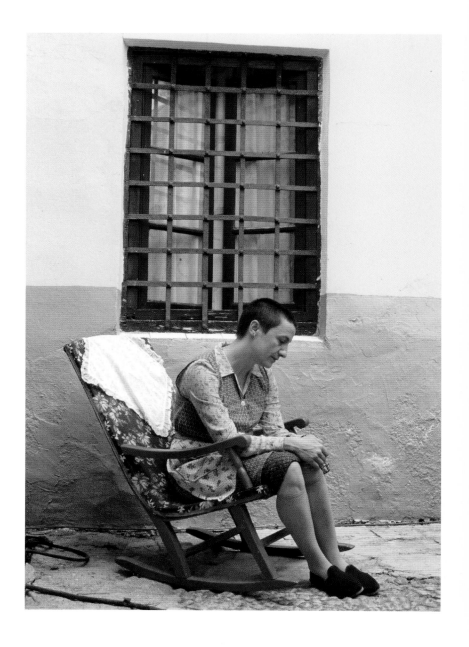

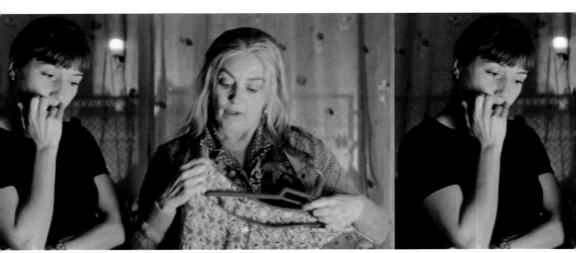

Lola Dueñas and Carmen Maura in *Volver*,
directed by Pedro Almodóvar, 2006

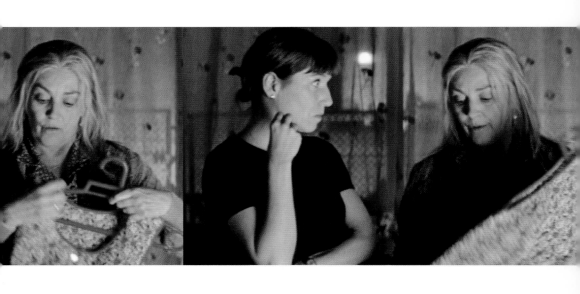

Marianne Faithfull in *Irina Palm*,
directed by Sam Garbarski, 2007

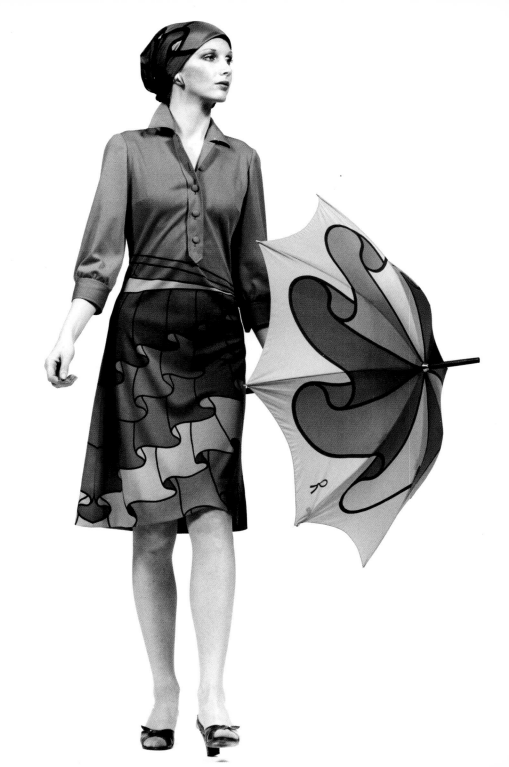

Roberta di Camerino, "Andalusia" shirtwaist,
hand-printed on polyester jersey, S/S 1972
collection. Archivio Roberta di Camerino

Roberta di Camerino, "Kimono" model,
hand-printed on polyester jersey,
S/S 1974 collection.
Archivio Roberta di Camerino

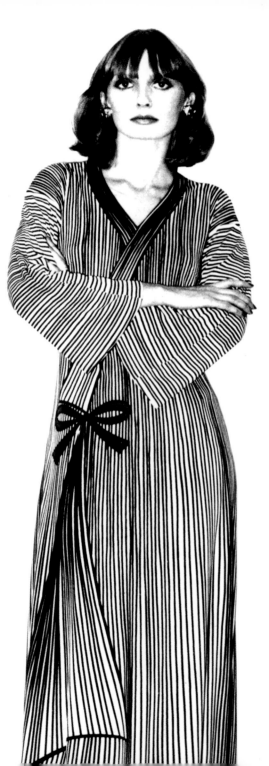

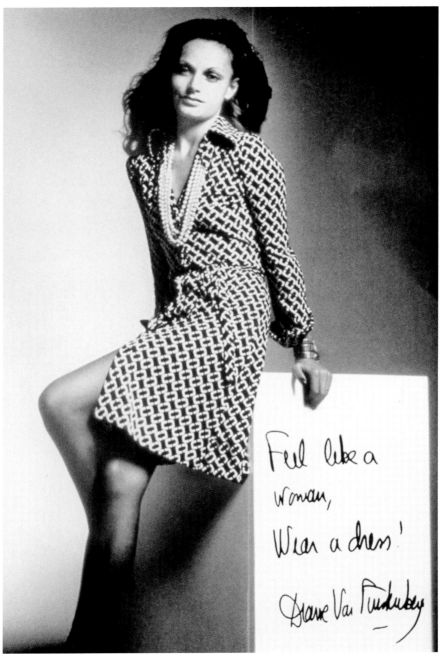

Feel like a
woman,
Wear a dress!
Diane Von Furstenberg

Diane von Furstenberg portrayed for her first advertising campaign
in a shirtwaist from her collection, photo Roger Prigent, 1972.
Diane von Furstenberg Archives

Diane von Furstenberg in her New York showroom, early 1970s.
Diane von Furstenberg Archives

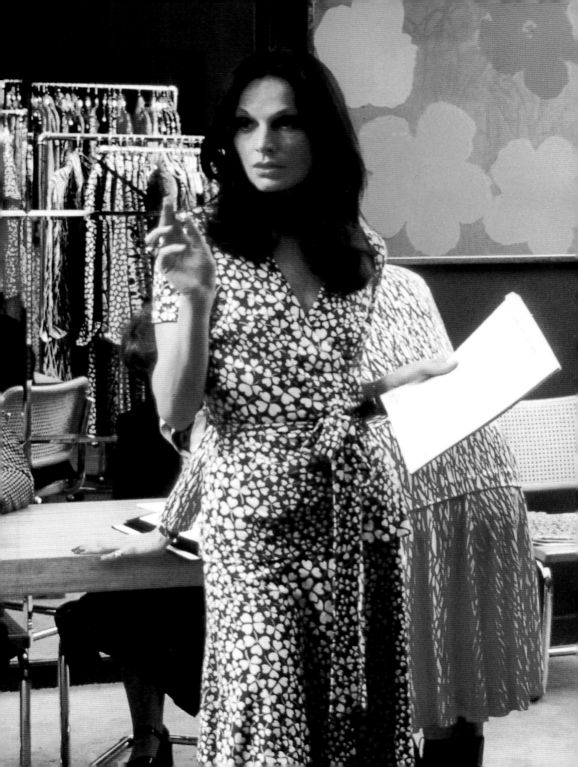

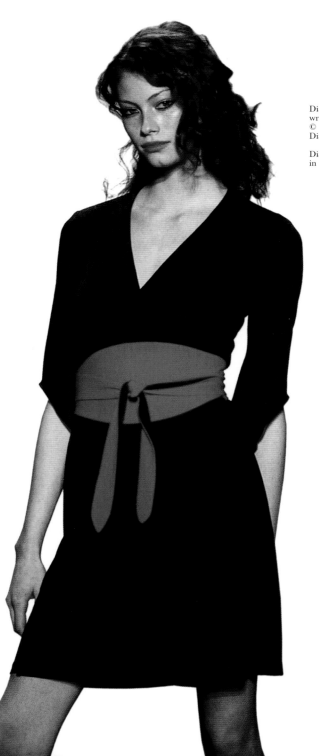

Diane von Furstenberg, "Geisha"
wrap dress. 2002 collection,
© photo Dan Lecca.
Diane von Furstenberg Archives

Diane von Furstenberg, wrap dress
in knitted cashmere, F/W 2007 collection

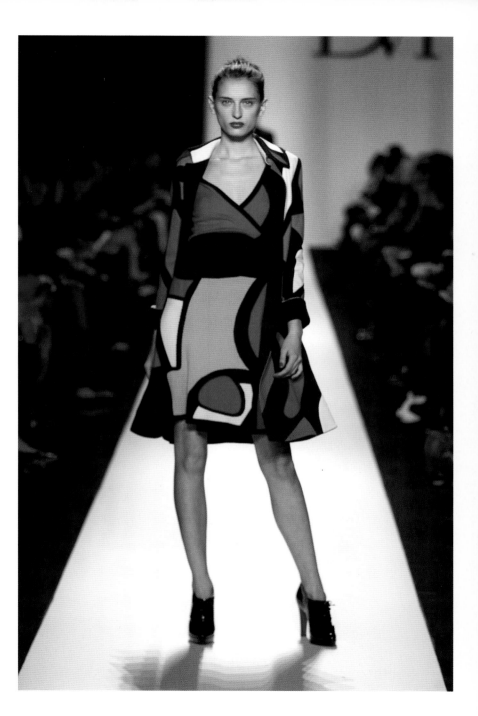

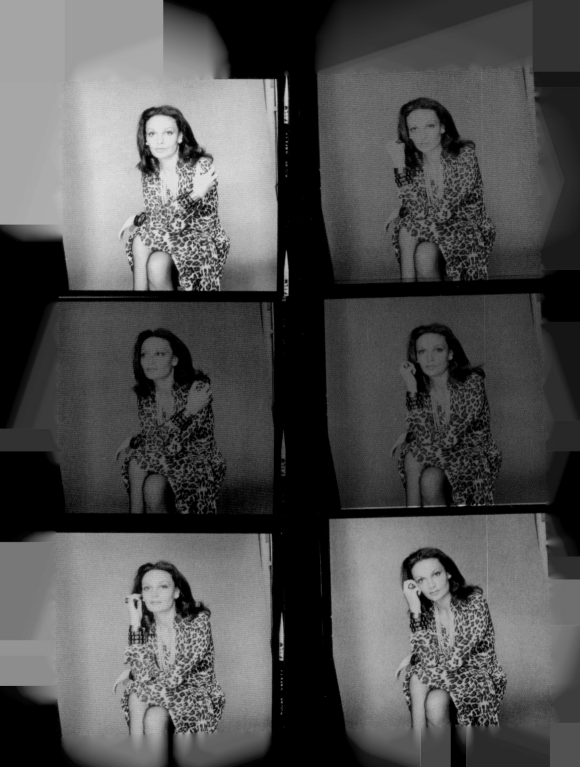

Manipulations of the contact prints of a photographic
portrait of Diane von Furstenberg.
Diane von Furstenberg Archives

Anna Sui, dress with apron over the top.
F/W 2007 collection

Pucci, wrap dress in Hava fabric.
F/W 2006/7 collection. Archivio Pucci

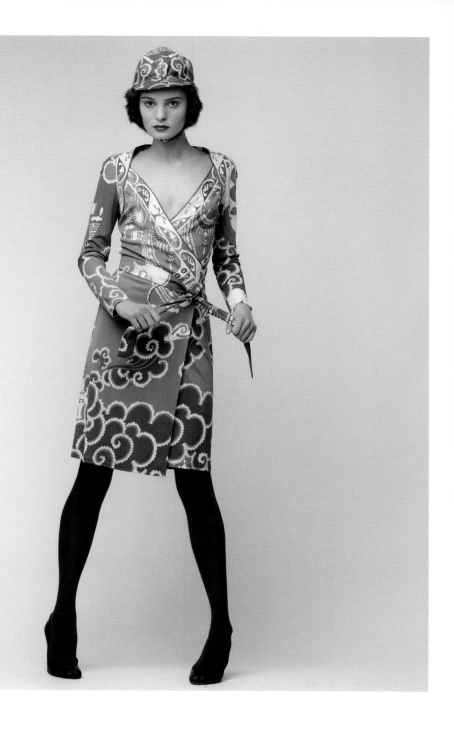

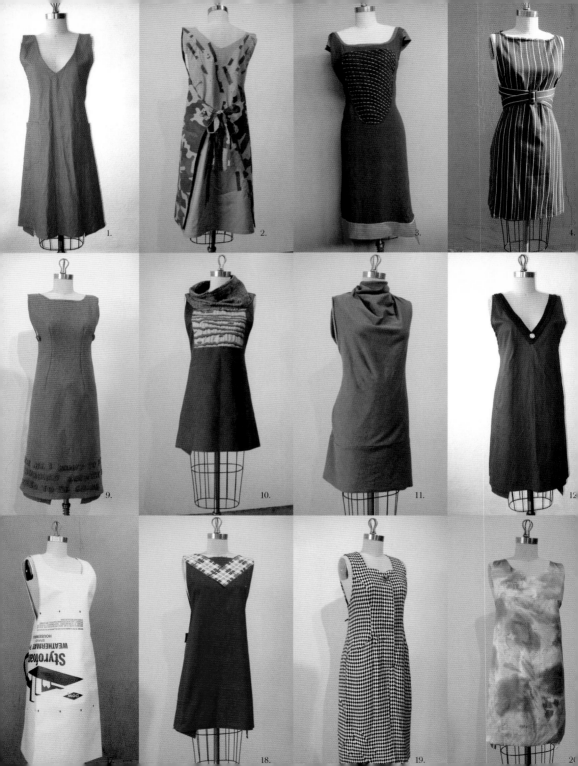

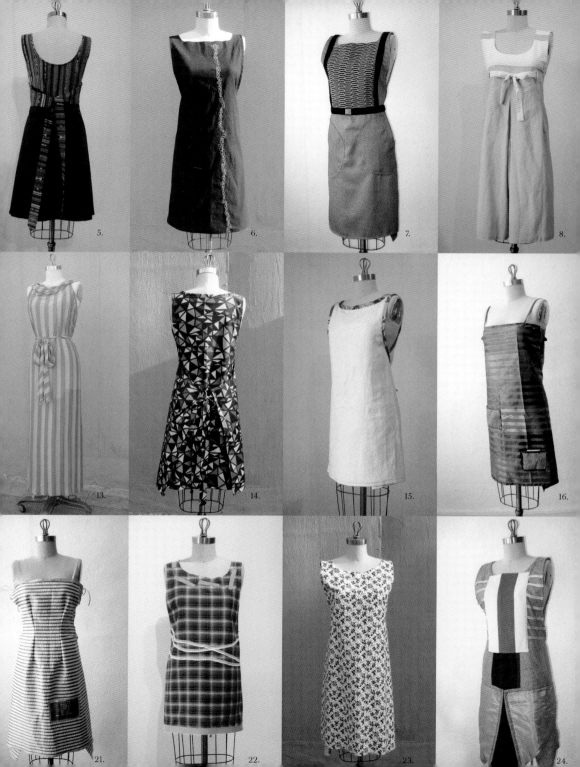

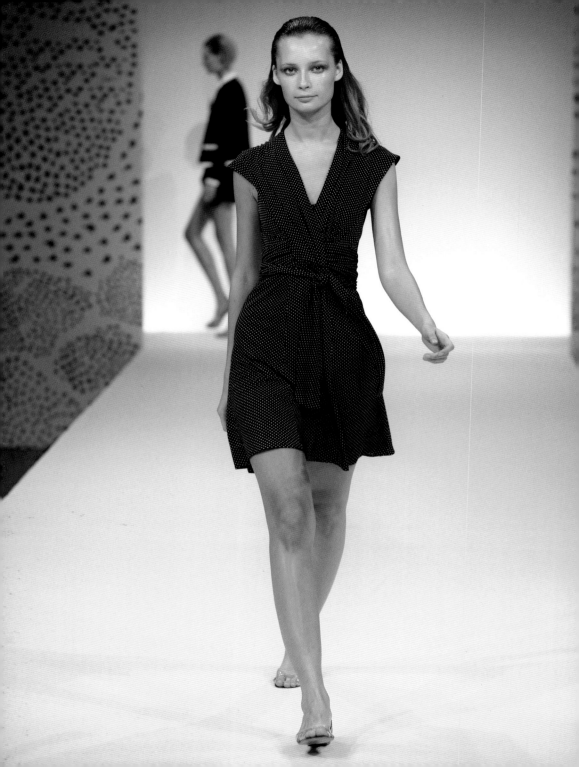

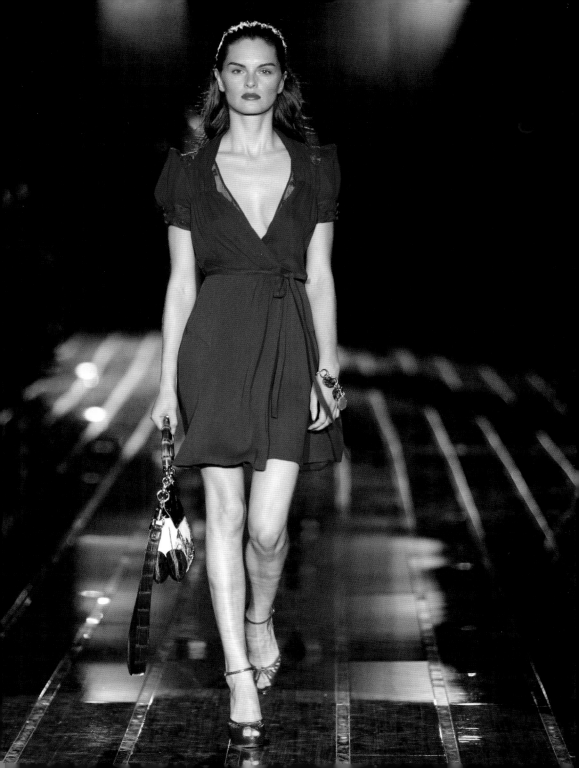

L'ARTE DELLA VESTAGLIETTA

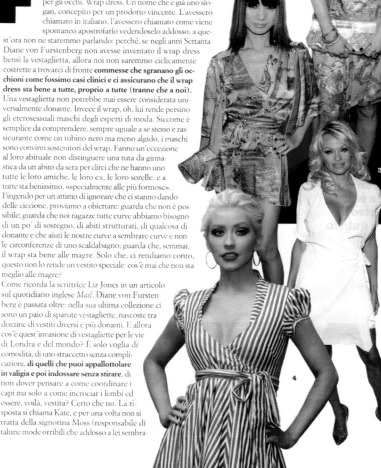

**"Ti impacchetta,
fa di te un regalo
per gli occhi". Le
star lo adottano e
commesse estasiate
propongono a
oltranza il capo
di stagione.
Ma una cronista
curvilinea non
ci sta (dentro).
E mette in dubbio
il dogma**

di *Guia Soncini*

Guia Soncini, "L'arte della vestaglietta"
("The Art of the Housedress"),
in *Io donna*, supplement to *Il Corriere
della Sera*, March 1, 2008

previous pages
ISSA of London, wrap dress. S/S 2008
collection. Issa of London Archives

Gucci, wrap dress. 2008 collection.
Archivio Gucci

F in dal nome è ingannevole: wrap dress, il vestito che ti avvolge, che ti impacchetta, che fa di te un regalo per gli occhi. Wrap dress. Un nome che è già uno slogan, concepito per un prodotto vincente. L'avessero chiamato in italiano, l'avessero chiamato come viene spontaneo apostrofarlo vedendoselo addosso, a quest'ora non ne staremmo parlando: perché, se negli anni Settanta Diane von Furstenberg non avesse inventato il wrap dress bensì la vestaglietta, allora noi non saremmo ciclicamente costrette a trovarci di fronte **commesse che sgranano gli occhioni come fossimo casi clinici e ci assicurano che il wrap dress sta bene a tutte, proprio a tutte (tranne che a noi)**. Una vestaglietta non potrebbe mai essere considerata universalmente donante. Invece il wrap, oh, lui rende persino gli eterosessuali maschi degli esperti di moda. Siccome è semplice da comprendere, sempre uguale a se stesso e rassicurante come un tubino nero ma meno algido, i maschi sono convinti sostenitori del wrap. Fanno un'eccezione al loro abituale non distinguere una tuta da ginnastica da un abito da sera per dirci che ne hanno uno tutte le loro amiche, le loro ex, le loro sorelle, e a tutte sta benissimo, «specialmente alle più formose». Fingendo per un attimo di ignorare che ci stanno dando delle ciccione, proviamo a obiettare: guarda che non è possibile; guarda che noi ragazze tutte curve abbiamo bisogno di un po' di sostegno, di abiti strutturati, di qualcosa di donante e che aiuti le nostre curve a sembrare curve e non le circonferenze di uno scaldabagno; guarda che, semmai, il wrap sta bene alle magre. Solo che, ci rendiamo conto, questo non lo rende un vestito speciale: cos'è mai che non sta meglio alle magre?
Come ricorda la scrittrice Liz Jones in un articolo sul quotidiano inglese *Mail*, Diane von Furstenberg è passata oltre: nella sua ultima collezione ci sono un paio di sparute vestagliette, nascoste tra dozzine di vestiti diversi e più donanti. E allora cos'è quest'invasione di vestagliette per le vie di Londra e del mondo? È solo voglia di comodità, di uno straccetto senza complicazioni, **di quelli che puoi appallottolare in valigia e poi indossare senza stirare**, di non dover pensare a come coordinare i capi ma solo a come incrociar i lembi ed essere, voilà, vestita? Certo che no. La risposta si chiama Kate, e per una volta non si tratta della signorina Moss (responsabile di talune mode orribili che addosso a lei sembra-

QUESTIONE DI CHILI

Le attrici: 1. Mia Maestro, 29 anni; 2. Katherine Heigl, 29; 3. Bijou Phillips, 27; 4. La scrittrice Imogen Lloyd Webber, 30, figlia di Andrew.

vano splendide) ma di miss Middleton, futura moglie del principe William. Kate veste quasi sempre in vestaglietta. E non importa che non sia mai sembrata particolarmente elegante a nessuno: ha conquistato il principe, diamine, quale prova migliore che la vestaglietta funziona? Risultato: diffusione epidemica del wrap tra le *sloaners*, le ragazze-bene di Londra (il nome viene dalla zona di Sloane square) la cui ambizione ad accasarsi con un residente di Buckingham palace è paragonabile al desiderio di una pariolina (dal quartiere residenziale Parioli, Roma) di convolare a ricche nozze con Piersilvio. Naturalmente le ragazze ricche sono avvantaggiate: essendo geneticamente magre e avendo il portamento fiero che dà la sicurezza sociale, persino con il wrap dress non sembrano delle orfane bisognose di cure mediche. Liz Jones sostiene che dimostrano il doppio dei loro anni, ma se anche fosse è comunque un'anzianità elegante: **sono state viste avvolte nel wrap figlie di buona famiglia come Jemima Khan e Tara Palmer-Tomkinson e Imogen Lloyd Webber**, oltre naturalmente a Kate Middleton e alla sorella (e futura cognata reale) Pippa, e - come per Marisa Berenson o Pat Cleveland che lo lanciarono indossandolo negli anni Settanta - su nessuna di loro il vestito a vestaglietta ha un effetto impietoso. Su noi culone, invece... Mentre uomini e commesse si ostinano a ripeterci che ci vogliono le curve per riempirlo, una di noi, una signora della buona società inglese intervistata dal mensile *Tatler*, deplora l'ineluttabilità del wrap nelle occasioni che contano: «Io ho molto seno, e quel vestito lo fa sembrare tutt'uno con lo stomaco».

Come sempre, le detrattrici sono una conferma del successo, e un accessorio indispensabile del trionfo. Ma paiono particolarmente accanite, forse frustrate dall'aver taciuto di fronte ai primi duecento «Ma sta bene a tutte», «Te lo metti e sei vestita». Ora si sfogano dicendo che è una scelta esteticamente pigra, poco donante, e soprattutto che, come si diceva ai tempi di scuola quando un capo era il più venduto della stagione, le vestagliette camminano da sole. Se ne vedo un'altra a un matrimonio urlo, giura una nobilastra intervistata da *Tatler*; l'altro giorno eravamo a pranzo in sei e al tavolo c'erano quattro

wrap, racconta un'altra. Tuttavia, probabilmente per non inimicarsi la futura erede al trono con un attacco totale al suo vestito preferito, le inglesi perlopiù fingono di credere che alle donne con curve il molto democratico wrap dress stia bene: «Siamo noi magre che sembriamo in accappatoio». Sarà. Ma l'accappatoio evoca immagini più strutturate e sexy di quelle rappresentate dai nostri bozzi di cellulite avvolti in un po' di stoffa troppo sottile per contenere e sostenere. A un quadro realistico di noi stesse con l'abito più modaiolo del momento mancano i bigodini, un marito con la canotta sporca di sugo al fianco, e il nome adatto per la prima cosa che ci siamo infilate: vestaglietta. ●

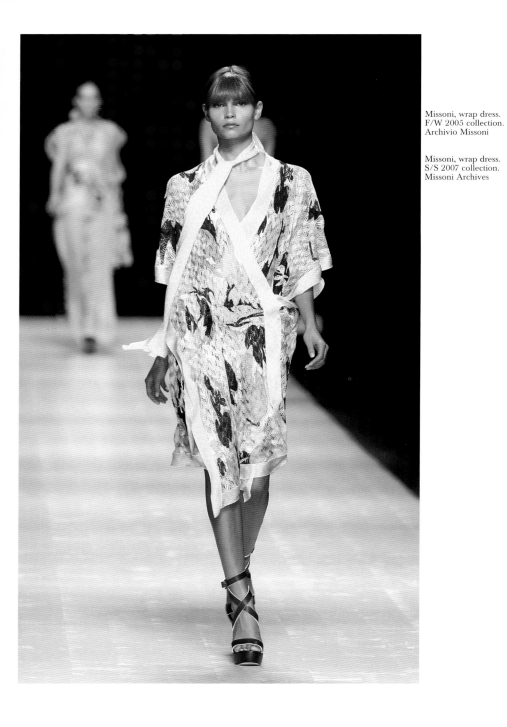

Missoni, wrap dress.
F/W 2005 collection.
Archivio Missoni

Missoni, wrap dress.
S/S 2007 collection.
Missoni Archives

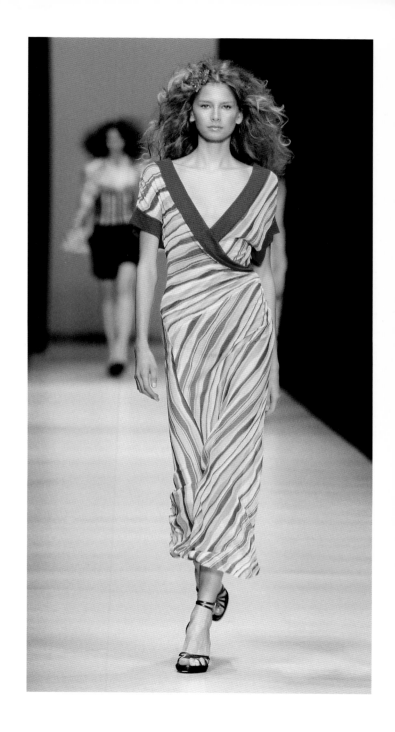

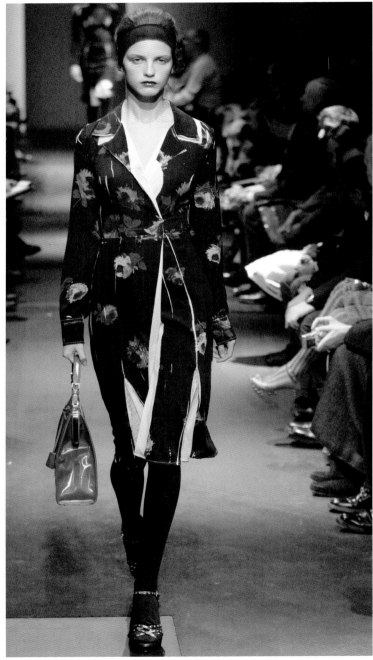

Prada, wrap dress.
F/W 2005 collection.
Archivio Prada

Prada, wrap dress.
S/S 2006 collection.
Archivio Prada

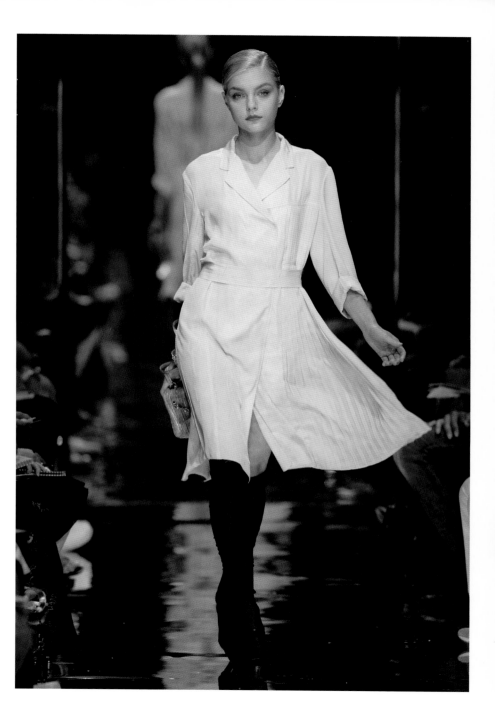

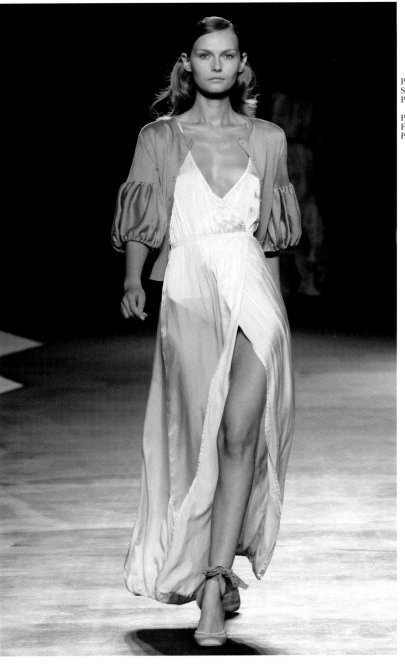

Paul Smith, wrap dress.
S/S 2006 collection.
Paul Smith Archives

Paul Smith, shirtwaist.
F/W 2006 collection.
Paul Smith Archives

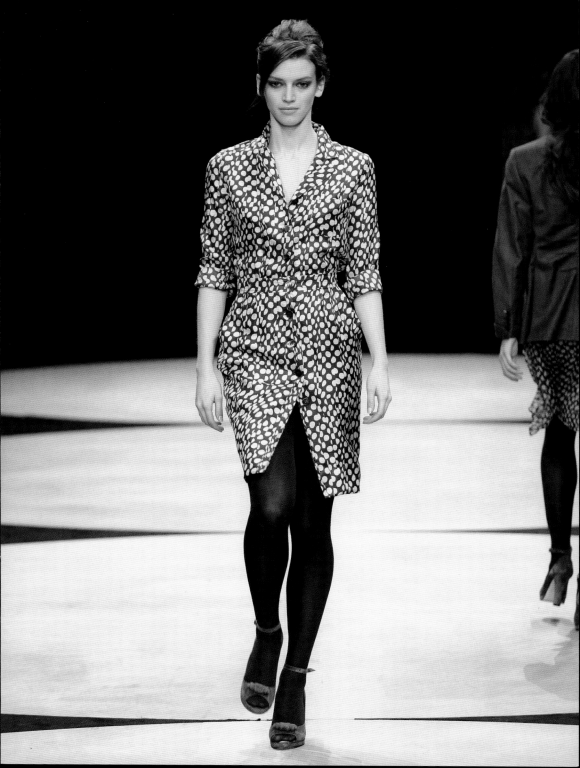

Jean-Paul Gaultier, satin wrap dress.
2008 collection. Jean Paul-Gaultier Archives

Versace, wrap dress. Cruise collection, 2008.
Archivio Versace

Bibliography

ARVIDSSON, ADAM, *Marketing Modernity: Italian Advertising from Fascism to Postmodernity.* London: Routledge, 2003.

ASH, JULIET; WILSON, ELIZABETH (eds.), *Chic Thrills: A Fashion Reader.* Berkeley: University of California Press, 1993.

BARTHES, ROLAND, *Système de la mode.* Paris: Seuil, 1957. Eng. ed: *The Fashion System,* trans. by Matthew Ward and Richard Howard. Berkeley: University of California Press, 1990.

BASSANINI, GISELLA (ed.), *Architetture del quotidiano.* Naples: Liguori, 1995.

BATTISTI, CARLO; ALESSIO, GIOVANNI, *Dizionario etimologico italiano.* Florence, Barbéra, 1955, 5 vols.

BEECHER, CATHARINE ESTHER, *A Treatise on Domestic Economy: For the Use of Young Ladies at Home, and at School.* New York: Harper & Brothers, 1845.

BINI, ELISABETTA; VEZZOSI, ELISABETTA (eds.), "Genere, consumi, comportamento negli anni cinquanta. Italia e Stati Uniti a confronto," i*Italia contemporanea,* no. 224, September 2001.

BLUTTAL, STEVEN (ed.), *Halston.* London: Phaidon Press, 2001.

BONAMI, FRANCESCO; FRISA, MARIA LUISA; TONCHI, STEFANO, Uniforme. Ordine e disordine 1950-2000. Florence-Milan: Fondazione Pitti Immagine Discovery-Charta, 2000. Eng. ed.: Uniform: Order and Disorder, Florence-Milan: Fondazione Pitti Immagine Discovery-Charta, 2000.

BRANCATO, GIOVANNA; MEDICI, LORENZA, "La stanza delle sculture radiose. Lineamenti di storia dello spazio cucina," in *Architetture del quotidiano*, ed. by Gisella Bassanini. Naples: Liguori, 1995, pp. 17-118.

BRUNETTA, GIAN PIERO, *Guida alla storia del cinema italiano 1905-2003.* Turin: Einaudi, 2003.

BURMAN, BARBARA (ed.), *The Culture of Sewing: Gender, Consumption and Home Dressmaking.* Oxford-New York: Berg, 1999.

BUTTAZZI, GRAZIETTA, *Moda. Arte, storia, società.* Milan: Gruppo editoriale Fabbri, 1981.

CAIN, JAMES, *The Postman Always Rings Twice.* New York: Knopf, 1934.

CASSOLA, CARLO, *Un cuore arido.* Turin, Einaudi, 1961. Eng. ed.: *An Arid Heart*, trans. by William Weaver: New York, Pantheon Books, 1964.

CATRICALÀ, MARIA, "Il catalogo Bocconi: vestirsi per corrispondenza a fine '800," in *Per filo e per segno. Scrittura di moda di ieri e di oggi*, ed. by Maria Catricalà. Rubbettino: Soveria Manelli, 2004.

CATRICALÀ, MARIA (ed.), *Per filo e per segno. Scrittura di moda di ieri e di oggi.* Rubbettino: Soveria Manelli, 2004.

CENTRO DESIGN MONTEFIBRE, "Introduzione e iconografia," in *Decorattivo 1975.* Milan: Montefibre, 1975.

COLAIACOMO, PAOLA; FRISA, MARIA LUISA, "Some Random Notes on Italian Fashion. The Fashion of Postmdernism" in Kaye Durland Spilker, Sharon Sakado Takeda, *Breaking the Mode: Contemporary Fashion from the Permanent Collection, Los Angeles County Museum of Art*, Milan: Skira International corporation, 2008, pp. 23-33.

COSTA, ANTONIO, "Cinema luogo di storia," in *Segnocinema*, no. 2, 1981.

D'AMICO DE CARVALHO, CATERINA; MARZOT, VERA; TIRELLI, UMBERTO, *Visconti e il suo lavoro.* Milan: Electa, 1995.

DE GRAZIA, VICTORIA, *Le donne nel regime fascista.* Venice: Marsilio, 1993.

DE GRAZIA, VICTORIA; FURLOUGH, ELLEN (eds.), *The Sex of Things. Gender and Consumption in Historical Perspective.* Berkeley-Los Angeles: University of California Press, 1996.

DURLAND SPIKER, KAYE; SADAKO TAKEDA, SHARON, "Breaking the Mode: Contemporary Fashion from the Permanent Collection, Los Angeles County Museum of Art", Milano: Skira International corporation, 2008.

ESPOSITO, SILVIA; MALDONADO, TOMÁS; RICCINI, RAIMONDA, "Condizione femminile e ideologia del comfort," in *Casabella*, yr. XLV, no. 467, March 1981, pp. 27-33.

FAETI, ANTONIO, *Gino Boccasile, La signorina grandi firme.* Milan: Longanesi, 1981.

FORGACS, DAVID; GUNDLE, STEPHEN, *Cultura di massa e società italiana 1936-1954*. Bologna: Il Mulino, 2007.

FORTUNATI, LEOPOLDINA; KATZ, JAMES; RICCINI, RAIMONDA (ed.), *Mediating the Human Body: Technology, Communication and Fashion*, Mahwah, New Jersey: Erlbaum, 2003.

FRANCHINI, SILVIA, *Editori, lettrici e stampa di moda. Giornali di moda e di famiglia a Milan dal "Corriere delle Dame" agli editori dell'Italia unita*. Milan: Franco Angeli, 2003.

FREDERICK, CHRISTINE, *The New Housekeeping: Efficiency Studies in Home Management*. Garden City, New York: Doubleday, Page & Company, 1913.

FRISA, MARIA LUISA; LUPANO, MARIO; TONCHI, STEFANO (eds.), *Total Living*. Florence-Milan: Pitti Immagine-Charta, 2002.

GIANNONE, ANTONELLA; CALEFATO, PATRIZIA, *Manuale di comunicazione, sociologia e cultura della moda*, vol. V, *Performance*. Rome: Meltemi, 2007.

HARDEN, ROSEMARY; TURNEY, JO, *Floral Frocks. A Celebration of the Floral Printed Dress from 1900 to the Present Day*. Woodbridge: Antique Collectors' Club, 2007.

HOLLANDER, ANNE, *Sex and Suits: The Evolution of Modern Dress*. New York-Tokyo-London: Kodansha International, 1994.

HORWOOD, CATHERINE, *Keeping Up Appearances: Fashion and Class between the Wars*. Stroud: Sutton Publishing, 2005.

JONES, LIZ, "RIP the wrap," in *The Daily Mail*, December 13, 2007.

KIDWELL, CLAUDIA; CHRISTMAN, MARGARET C., *Suiting Everyone: The Democratization of Clothing in America*. Washington, DC: Smithsonian Institution, 1974.

KIRKLAND, SALLY, "Claire McCardell", in *American Fashion*, ed. by Sarah Tomerlin Lee. New York: Quadrangle Books, 1975.

KNEELAND, NATALIE, *Aprons and House Dresses*. Chicago-New York: A.W. Shaw Company, 1925.

LE CORBUSIER, *L'Art decoratif d'aujourd'hui*. Paris: Les Editions G. Crés et C.ie, 1925.

LEVI PISETZKY, ROSITA, "Storia del costume in Italia", in *Enciclopedia della moda*. Rome: Istituto dell'Enciclopedia italiana Giovanni Treccani, 2005, 3 vols. [orig. ed. 1964-69].

MADDOCKS, MILDRED, "Good Housekeeping Institute", in *Good Housekeeping*, September 1917, New York, pp. 74, 95.

MAZZONIS, FILIPPO, "Casa e lavoro: ruoli e modelli nelle riviste per le donne", in *La stampa periodica romana durante il fascismo (1922-1945)*, ed. by Filippo Mazzonis. Rome: Istituto nazionale di studi romani, 1998.

MAZZONIS, FILIPPO (ed.), *La stampa periodica romana durante il fascismo (1922-1945)*. Rome: Istituto Nazionale di Studi Romani, 1998.

MAZZUCA, ALBERTO, "Alba veste bene," in *Il Sole 24 ore*, December 15, 1985.

MCCARDELL, CLAIRE, *What Shall I Wear? The What, Where, When, and How Much of Fashion*. New York: Simon and Schuster, 1956.

MCDOUGALL, ISABEL, "An Ideal Kitchen", in *The House Beautiful*, December 13, 1902, pp. 27-32.

MEANO, CESARE, *Commentario dizionario italiano della moda*. Turin: Ente Nazionale della Moda, 1936.

MENKES, SUZY. "From Homely to Hot", in *The New York Times*, January 17, 1993.

MIGLIORINI, BRUNO, *Storia della lingua italiana*. Florence: Sansoni, 1961.

MONDELLO, ELISABETTA, *La nuova italiana. La donna nella stampa e nella cultura del Ventennio*. Rome: Editori Riuniti, 1987.

MORRIS, BERNARDINE, "Basic Dresses in Sexy Prints And Washable," in *The New York Times*, April 18, 1975.

MORSIANI, PAOLA; SMITH, TREVOR, *Andrea Zittel. Critical Space*. Munich: Prestel Publishing, 2005.

PARIS, IVAN, *Oggetti cuciti. L'abbigliamento pronto in Italia dal primo dopoguerra agli anni Settanta*. Milan: Franco Angeli, 2006.

PARTINGTON, ANGELA. "Popular Fashion and Working-Class Affluence," in *Chic Thrills: A Fashion Reader*, ed. by Juliet Ash and Elizabeth Wilson. Berkeley: University of California Press, 1993.

Patterns for Blouses and Dresses. Women's Institute of Domestic Arts and Sciences. ?Great Britain?, International Educational Publishing Co., 1917.

PAULICELLI, EUGENIA, *Fashion under Fascism. Beyond the Black Skirt*. Oxford-New York: Berg, 2004.

PAVESE, CESARE, *La spiaggia*. Turin, Einaudi, 1968 [orig. ed. 1941]. Eng. trans. by R.W. Flint, *The Beach*, in *The Selected Works of Cesare Pavese*, New York: New York Review of Books, 2001.

PETROCCHI, POLICARPO, *Novo dizionario universale della lingua italiana.* Milan: F.lli Treves, 1931, 2 vols.

PIRANDELLO, LUIGI, "O di uno o di nessuno", in id. *Maschere nude,* ed. by Italo Borzi and Maria Argenziano. Rome, Newton Compton, 1993 [orig. ed. 1929].

"Plan for Women's Aid", in *The New York Times,* June 22, 1917, p. 3.

RENNOLDS MILBANK, CAROLINE, *New York Fashion. The Evolution of American Style.* New York: Harry N. Abrams, 1989.

RICCI, STEFANIA (ed.), *Emilio Pucci.* Florence, Skira Editore, 1996.

RUTHERFORD, JANICE WILLIAMS, *Selling Mrs. Consumer: Christine Frederick and the Rise of Household Efficiency.* Athens (Georgia), The University of Georgia Press, 2003.

SCHIRO, ANNE-MARIE, "A dress business grows, but stays in the family," in *The New York Times,* August 16, 1980.

SONCINI, GUIA, "L'arte della vestaglietta", in *Io Donna,* supplement to *Il Corriere della Sera,* March 1, 2008, pp. 179-82.

SULLIVAN, JOAN L., "In Pursuit of Legitimacy: Home Economists and the Hoover Apron in World War I," in *Dress. The Journal of the Costume Society of America,* vol. 26, 1999, pp. 31-46.

TALLEY, ANDRÉ LEON, *Diane Von Furstenberg. The Wrap.* Paris: Assouline, 2004.

TASCA, LUISA; HILWIG, STUART, "The 'Average Housewife' in Post-World War II Italy," in *Journal of Women's History,* vol. 16, no. 2. Baltimore: The Johns Hopkins University Press, 2004, pp. 92-115.

TOMERLIN LEE, SARAH (ed.), *American Fashion.* New York: Quadrangle Books, 1975.

TRIANI, GIORGIO, *Pelle di luna, pelle di sole. Nascita e storia della civiltà balneare, 1700-1946.* Venice: Marsilio, 1988.

TRIANI, GIORGIO (ed.), *Casa e supermercato. Luoghi e comportamenti del consumo.* Milan: Elèuthera, 1996.

VARNEDOE, KIRK, "Advertising", in *High and Low. Modern Art and Popular Culture,* ed. by Kirk Varnedoe and Adam Gopnick. New York: Museum of Modern Art, 1990.

VARNEDOE, KIRK; GOPNICK, ADAM (eds.), *High and Low. Modern Art and Popular Culture.* New York: Museum of Modern Art, 1990.

VAUGHAN, HEATHER, "Icon: Tracing the Path of the 1950s Shirtwaist Dress," in *Clothesline: The Online Journal of Costume and Dress*, ed. by Elizabeth Walton: http://www.clotheslinejournal.com/shirtwaist.htm, 2005.

VEBLEN, THORSTEIN, *The Theory of the Leisure Class*. Harmondsworth: Penguin, 1979 [orig. ed. 1899].

WIGLEY, MARK, *White Walls, Designer Dresses: The Fashioning of Modern Architecture*. Cambridge, Mass., The MIT Press, 2001.

WILSON, ELIZABETH, *Adorned in Dreams: Fashion and Modernity*. London-New York: I.B. Tauris, 2003.

YAPELLI, TINA, [Introduction], in *A-Z for You, A-Z for Me*, catalogue of the exhibition at the University Art Gallery, San Diego. San Diego: San Diego State University, 1998.

YOHANNAN, KOHLE; NOLF, NANCY, *Claire McCardell. Redefining Modernism*. New York: Harry Abrams, 1998.

ZITTEL, ANDREA, "Shabby Clique," in *Artforum*, 211, summer 2002.

Magazines

La Moda Illustrata. Milan: Sonzogno, 1920-39.

Websites

http://www.clotheslinejournal.com/shirtwaist.htm
http://www.dailymail.co.uk/pages/live/femail/article.html?in_article_id=501589&inpageid=1879
http://www.fashionmagazine.it/news/pages/show.prl?id=14155
http://nationalhumanitiescenter.org/pds/gilded/progress/text4/frederick.pdf
http://www.smockshop.org/

Photolitography
Fotolito Veneta, San Martino Buonalbergo (Verona)

Printed by
Grafiche Nardin, Ca' Savio - Cavallino - Treporti (Venice)
for Marsilio Editori® s.p.a., Venice

EDITION

10 9 8 7 6 5 4 3 2 1

YEAR

2008 2009 2010 2011 2012